IMAGES
of America

AROUND
LAKE NORMAN

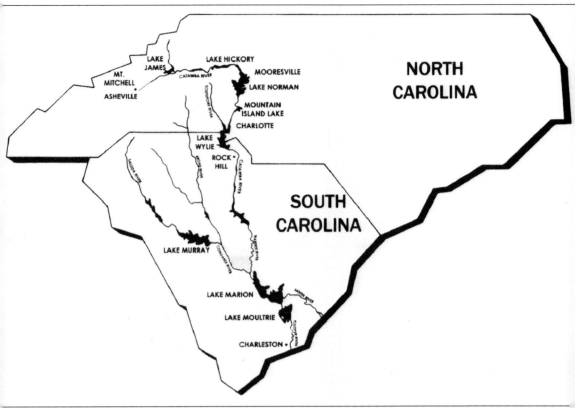

The story of Lake Norman began in 1895 when the Duke brothers began to learn about electricity, a new power source that had the potential to revolutionize manufacturing, especially in the South. They looked at the Catawba River's 220-mile length and saw a way to generate that power and build industry in North and South Carolina. The Dukes were not the only brothers with plans to harness the river. Drs. Gill and Richard Wylie acted on their belief in hydroelectric power and established the Catawba Power Company with a dam and power station near Rock Hill, South Carolina. When they joined forces in 1903 to form the Southern Power Company, the region's industry, business, and population began to grow and change into a dynamic economy. Their dams and power stations transformed the landscape, revitalized the economy, and provided a recreational mecca for millions of people. Steam plants, spinnakers, and striped bass—you can find it all on beautiful Lake Norman. (Courtesy of author.)

ON THE COVER: The waters of Lake Norman crossed county boundaries and created a community of its own. Using docks instead of driveways, Lake Dwellers visited neighbors and friends on a regular basis. Lake Norman Power Squadron mixed business with pleasure by having meetings and social events at one of the most accessible and convenient locations, the home of Bob and Louise Cashion. Their home in the country on Brawley School Road became a peninsula surrounded by the waters of the new lake. The Cashions, already commuters to their businesses 30 miles away, were the first to travel by water as a daily commute by boating to Holiday Harbor Marina and driving to Cornelius. Families like the Cashions are true Lake Dwellers, those who found the lake at their front door. Lake Norman, created to produce power for industries in North and South Carolina, became the "Inland Sea," as described by Duke Power Company. It is a sparkling world for boaters and those who love the splash of a striped bass, the lapping of waves, and beautiful sunrises and sunsets. Beautiful Lake Norman is more than just a place; it's home. (Courtesy of author.)

IMAGES of America
AROUND LAKE NORMAN

Cindy Jacobs

ARCADIA
PUBLISHING

Copyright © 2008 by Cindy Jacobs
ISBN 978-0-7385-5396-2

Published by Arcadia Publishing
Charleston, South Carolina

Printed in the United States of America

Library of Congress Catalog Card Number: 2007943566

For all general information contact Arcadia Publishing at:
Telephone 843-853-2070
Fax 843-853-0044
E-mail sales@arcadiapublishing.com
For customer service and orders:
Toll-Free 1-888-313-2665

Visit us on the Internet at www.arcadiapublishing.com

This is only part of a story of people who traveled "over the river and through the woods" to claim a spot on the shores of beautiful Lake Norman. Even though developing towns was not their plan, they brought a sense of the importance of community to the 520 miles of shoreline and established connections with their often-distant neighbors. It is thanks to the energy, dedication, and foresight of individual people that this place we call Lake Norman is a reality. The list includes Buck Teague, Miles Forbes, Milt Cox, Bud Lancaster, Louis Klutz, Brooks Lindsey, Bob Randall, Norman Junker, James Jennings, John Hecht, Harold Little, Joe Knox, Russell Knox, Griffin Kale, Sandy McKeel, Mike Naramore, Curtiss Torrance, Elmer Horton, Don Sweet, Buff Grier, Jim Brady, Bob Hudgins, Norman Lutz, Jack Bennett, Roy Creamer, Edward Kipka, Gene Kerley, Mack Mills, Rex Welton, Miles Boyer, Bill Furr, and Bill Lee, just to name a few.

Contents

Acknowledgments		6
Introduction		7
1.	The Great Creek	9
2.	Harnessing the Catawba River	23
3.	The Port City of Lake Norman	45
4.	Fun at the Pond	63
5.	Who's Minding the Lake?	87
6.	Hurricane Hugo	103
7.	Legends, Stories, and What was That?	109
8.	Port City to Race City	119

ACKNOWLEDGMENTS

A simple thank you is not adequate to describe my appreciation to the people who have shared part of their lives with me so that I may share it with others. These fellow citizens shared their collections of images as well as their recollections to support this effort to make the history of beautiful Lake Norman available to those who seek knowledge and information. I hope that this collection of images and information will provide a basis for research and storytelling for the entire four-county area and add to the pioneering efforts of Diana and Bill Gleasner.

This book could not have been published without the guidance and help of Arcadia Publishing senior acquisitions editor Maggie Bullwinkel and the support of my friends, neighbors, and colleagues. Unless otherwise noted, photographs were taken by the author.

Thank you to Abigail Jennings, Bill Keeter, Tommy Whiteside, Carroll Rempe, Lake Norman Power Squadron, Bobby Leagon, Frances Whiteside, Mooresville mayor emeritus Joe Knox, Lib Knox, Betty Boone, Billie Harwell, Jean Towel Gibson, Fannie Whitlow Kipka, Jane Marlow Cagle, Betty Puckett, Bob Lineberger, Sara Kipka Sides, Mary Kipka Brawley, Pearl Troutman Alexander, Francella Craven Kerr, Bobbie Johnston Powers, Mary Mack Mills Benson, Kay Kipka Jones, Side Mitchell Mack Sr., Bernard Christenbury, Rusty Jacobs, Buddy Millsaps, H. Mike Cook, Clyde Millsaps, Reid Sherrill, Erleen Mills Christenbury, Karen Kistler, Rodney Benfield, Virginia Hart Edmiston, Charlie Roberts, Janet Kerr Ramey, Al Jones, Leigh Lowder Whitfield, Bill Edmiston, Betty Jo Gabriel Lowrance, Richard Newton, Spencer McLaughlin, Rena Bishop, Elizabeth Owens Whitlow, Betty Jo Newton, Tim Cook, Dale Gowing, Nancy Baker, Sylvia Smith, Tom McLaughlin, Libby McLaughlin, Connie Sykes, Luellen Goodnight Masingo, Hugh Sykes, Ben Sykes, Pam Beaver, Bill McLaughlin, Margaret McLaughlin Goodnight, and the Wal-Mart of Mooresville photo lab staff.

INTRODUCTION

Beautiful Lake Norman—the Inland Sea—was born in 1964. On a warm Sunday afternoon, a new group of Catawba River inhabitants, Lake Dwellers, are relaxing on the shores of Lake Norman after a busy weekend. Most arrived on Friday afternoon with their coolers, sleeping bags, and camping equipment, traveling from Mooresville, Charlotte, Statesville, Concord, Winston-Salem, Lincolnton, and Salisbury. The name of the game is fun, but work must be done to clear the brush, build the docks, and construct cabins. Some build concrete boat ramps, others bring Styrofoam and oil drums for floating docks. There are inner tubes, charcoal grills, extension cords, and tools of all kinds. These pioneers are getting ready for next summer's festive outings on land and sea.

Activity gave birth to new businesses to supply Lake Dwellers with items they needed for a weekend in the country. If Kiser's Island was the destination, Terrell Country Store offered everything from canned goods to fresh produce. Lineberger's store offered gas and groceries, while Mooresville's Joe Trigg made the very best hot dogs, five for $1. Miles Forbes opened Midway Marina for lake access, food, gas, and fishing licenses. In the shadow of the Highway 150 bridge, Midway was a stopping point for east-west traffic. H and S Lumber on Brawley School Road had the materials to build docks and piers. Wherry and Rena Junker's Wher-Rena Marina offered bait, tackle, and boat ramps. Waterfront dining could be enjoyed at the Galley, while Ham 'n' Eggs and Knox's Grill offered breakfast and everything else for the hungry Lake Dweller anytime! Earl Teague's Outrigger Harbor offered campgrounds and a Polynesian tour boat that joined the *Robert E. Lee* riverboat on the new waters. Duke Power Company provided access and boat ramps at places like the Pinnacle Access Area, whose boulders were part of the original quarry used to build the first paved road to and from the river.

By 1975, the lake was a sparkling world of sailors, skiers, and fishermen having the time of their lives. Their docks were complete, with boats of all sizes filling the slips. Cozy cabins provided shelter for families and friends. These modern Lake Dwellers are families from towns throughout the region, arriving on Interstate 77 exits from Troutman to Huntersville. Often lake neighbors are town neighbors who followed each other to the new vacation spot. More often, they were new friends with a love of the lake in common. Lake Norman Yacht Club was a place for Optimist Prams and South Atlantic Yacht Racing Association (SAYRA) regattas. The Lake Norman Marine Commission, Lake Norman Power Squadron, and the Coast Guard Auxiliary paid close attention to boating safety. Bill Kale offered gas, bait, and lunch from his marina at Buffalo Shoals while sharing memories and good advice with fishermen and visitors. Kale remembers the Flood of 1916, when barns and houses floated down the Catawba in the rushing waters.

John and Bob Hecht, James Jennings and others are buying and selling lake property for homes and businesses by 1970. "Realtor" became a common word, and Lake Dwellers looked forward to the development that would bring the comforts of home to the lake. By 1995, the river was a world of thousands of permanent residents living in neighborhoods with paved streets, visiting shops with myriad goods and services and enjoying new lakeside restaurants.

Marshall Steam Station's smokestacks and the McGuire Nuclear Station's towers bring us to the reality that this is a working lake designed for power on the Catawba, the "most electrified river in the nation," according to Duke Power. The casual observer must reach to remember that this place is new, a manmade alteration of the Great Creek, as the natives called it.

One a source of food, water, and transportation, the river is now Lake Norman, the largest freshwater lake in North Carolina. While it has changed, it is still, as always, the Catawba River.

The Great Creek was named for the people who lived by it, the Catawba Nation, known in their own language as the *Kawahcatawbas* or "the people of the river." These first Lake Dwellers set the stage for community development based on agriculture and industry and dependent on the river. New settlers arrived from Ireland, Scotland, England, Germany, and other parts of Europe

to settle the new land known as America. From their coastal settlements, they moved inland, finding fertile lands in the Catawba and Yadkin River valleys.

They made their homes and farmed the land along the Catawba River, establishing churches, schools, and communities. By the time of the Revolutionary War, the valley was well established. Charlotte was a town of more than 150 families, and settlers were building farms in the places that would become Mooresville, Lincolnton, and Statesville. As their nation grew, they were called to service during the Revolutionary War. Gen. William Lee Davidson, whose home still stands along Davidson Creek, led his troops against the British at Cowans Ford, slowing Cornwallis's advance toward Guilford Courthouse. Davidson was killed in the Battle of Cowans Ford, but his legacy lives on in the contributions of his descendants and those of his neighbors.

Communities grew slowly around churches like Centre Presbyterian in Iredell County. The Centre congregation worked to establish other churches and schools like Crowfield Academy. The Civil War again called upon citizens to leave their homes and go to war. Thousands did not return to their families, while others returned to find their communities in ruins. Even though the Civil War left the economy nearly bankrupt, the return of the railroad to places like Moore's Siding brought prosperity, new citizens, and economic opportunity.

Mooresville became an incorporated town only one year after the return of the railroad in 1872. Business and industry followed, with the economic foundation of the town established by the Mooresville Cotton Mills in 1893. This development set the stage for the Farmers Warehouse and Oil Mills and the Mooresville Cooperative Creamery to stabilize the economy and take the town into the 20th century on a solid footing. The heaviest steel bridge in the state was built as a toll bridge to connect a new road through Mooresville with towns in Catawba and Gaston Counties. Iredell County established connections at Buffalo Shoals and smaller locations for the transport of people, goods, and services to surrounding counties.

Industry in the Piedmont used waterpower to operate increasingly complex machinery to process cotton, corn, and wheat. Steam plants run by coal made textile manufacturing a reality for mill owners in Lincolnton, Mooresville, Long Island, and East Monbo. As their operations grew, so did their demand for power.

James Buchanan "Buck" Duke and Benjamin Duke of Durham's American Tobacco Company saw a future in the textile industry in the Carolinas. They understood the concept of manufacturing and realized that increasing mechanization required a reliable source of power. That power, they believed, was locked in the flowing rivers of the Piedmont region of North and South Carolina. Even though the concept of electricity was new and relatively unknown, the Dukes invested in textile mills and began to purchase Catawba River bottomland at the end of the 18th century. They believed that the water could be used to generate the electrical power needed to provide clothing and cotton goods for a growing nation and generate a rebirth of the South's economy. Duke set about to harness the power of the river as others worked to tame the countryside for growing communities. To insure their growth and prosperity in the 20th century, mill owners and community leaders looked for reliable sources of water and power. Piedmont communities found both in the Catawba River.

Lake Norman today is a changed world. As always, the water is used to connect people and places for commerce, civic action, and recreation. Water vehicles of all sizes and shapes travel the liquid highway for club meetings, family dinners, work, and entertainment. There are places to go, people to see, and things to do. Sometimes it seems that everyone is doing everything at the same time. And sometimes, in the early morning and late afternoon, the lake becomes quiet and pristine, without sound or movement.

It is in those moments the river speaks, telling the story of the Catawbas, the heroes of the Revolution, the farmers and settlers, the entrepreneurs and manufacturers, the swimmers and fishermen, and the builders and leaders of communities small and large. It remembers the good news of the first bridge and eagles' nests and the bad news of the Flood of 1916 and Hurricane Hugo. This river, the "Cattywaba," tells the story of people who, finding themselves in one place, decided to make it home.

One

THE GREAT CREEK

The Catawba River starts in the high country near Mount Mitchell as a trickling stream. Flowing east and south toward the ocean, it makes its was through the rich farmland of the North Carolina Piedmont. Centuries ago, Native Americans known as the Catawbas traveled south along the Kentucky River to the Piedmont of North Carolina. Sharing the land with the Cherokees, they made homes near a water source, taking what the river provided. The river has a watershed of 4,750 square miles, ending at Lake Wateree in South Carolina, where it becomes known as the Wateree River. (Courtesy of Bobby Leagon.)

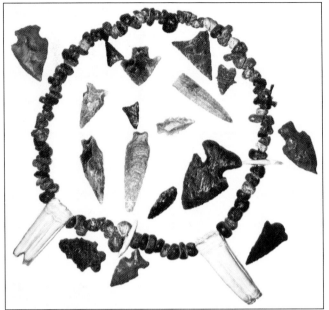

Artifacts are found all along the length of the river, indicating where and how the Catawba lived. Part-time archeologists Ray Boone and Tim Fries have collected arrowheads, decorative necklaces, pottery shards, and other artifacts in places near the original riverbed and inland toward Mooresville. They are evidence that large communities farmed the land, hunted in the dense forests, and fished in the river. Native Americans called the river the "Great Creek." Later the river was named for them. (Courtesy of Betty Boone.)

European settlers moved inland to find rich farmland and mild winters in areas near the river. They formed small communities around churches and schools. Among the original pioneers from Pennsylvania, New Jersey, and Maryland who settled on the east side of the Catawba River were George Davidson, Rev. John Thomson, Moses White, Hugh Lawson, William Morrison, and Andrew Allison. The Thomson, White, and Lawson homesites, located on the waters of Catawba, are now under the waters of Lake Norman. John Oliphant's gristmill, located on Oliphant's Creek, served the needs of these and other early settlers. By the time of the Revolutionary War, the valley was well established, and its men formed an active local militia. (Courtesy of Stallings-Sigmon Collection.)

Of the battles recorded, one of the most dramatic occurred at the site of Cowans Ford on the Catawba River. British general Charles Cornwallis, in pursuit of Gen. Nathanael Greene, was met by a regiment of Catawba Valley farmers. Their leader was Gen. William Lee Davidson, a member of Centre Presbyterian Church in Mount Mourne. He and his men fought valiantly and were successful in detaining Cornwallis, but Davidson was killed by a bullet to the heart. He fell from his horse in the middle of Cowans Ford. General Davidson is recognized as one of North Carolina's true Revolutionary War heroes. A monument honoring Davidson is located near the present site of the Cowans Ford Dam. Davidson College professor Chalmers Davidson wrote a definitive study of the general, *Piedmont Partisan*, that describes him in terms of family, faith, and honor.

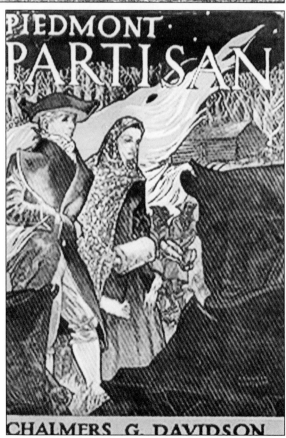

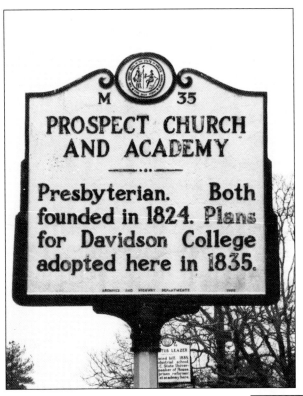

In 1835, Augustus Leazer led a meeting at Prospect Presbyterian Church to make decisions about the future of schools. The school in question is now known as Davidson College. The minutes of the Presbytery of Concord for August 1835 record, "It was resolved that the Manual Labor Institution which we are about to build be called Davidson College as a tribute to the memory of that distinguished and excellent man Gen. Wm Davidson, who in the ardor of patriotism, fearlessly contending for the Liberty of his country fell universally lamented in the Battle at Cowan's Ford."

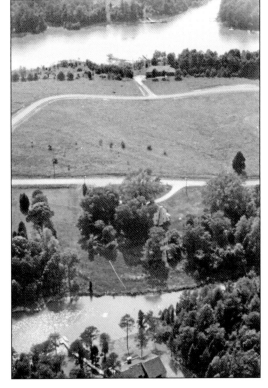

General Davidson's home stands today on the shores of Lake Norman in Davidson Creek. After his death, his body was removed from the water and buried in the Hopewell Presbyterian Church cemetery. In 1990, Rev. Jeff Lowrance discovered Davidson's wallet in England and returned it for exhibit.

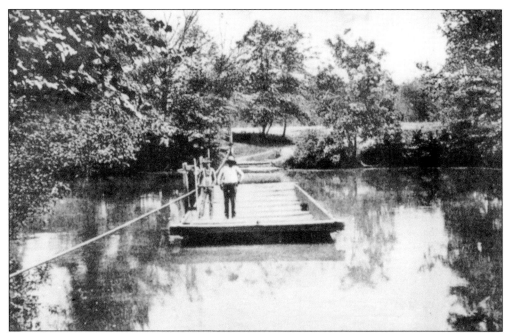

Over the years, towns on opposite sides of the river found ways to travel and buy and sell goods and services. Before bridges, people crossed the river on ferries and at narrow, shallow fords. Adam Sherrill's ford linked the communities of Mooresville, Terrell, and Sherrills Ford so that goods like tobacco and cotton could be manufactured and traded. (Courtesy of Stallings-Sigmon Collection.)

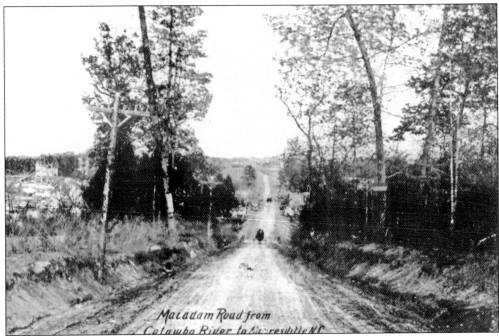

By 1900, Mooresville residents could travel to and from the Catawba River on a modern roadway. A macadam road (now Highway 150 West) was built for wagons traveling to the Catawba River ford leading to Catawba County and points west. The macadam method of road building used stones laid evenly and tightly so that they covered the soil base and formed a hard surface. These roadways were designed to support pedestrians and horse-drawn traffic. With the increasing popularity of automobiles, the road structure was reinforced and later replaced with more-substantial aggregate and concrete. (Courtesy of Stallings-Sigmon Collection.)

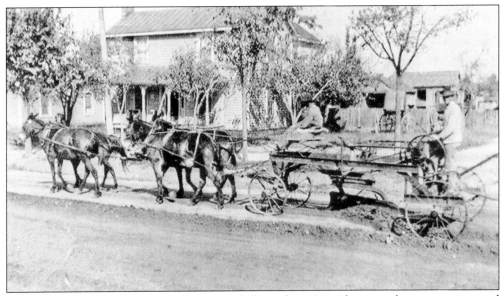

Macadam roads required maintenance to smooth the surface. Horse-drawn road scrapers maintained the roadways. (Courtesy of Stallings-Sigmon Collection.)

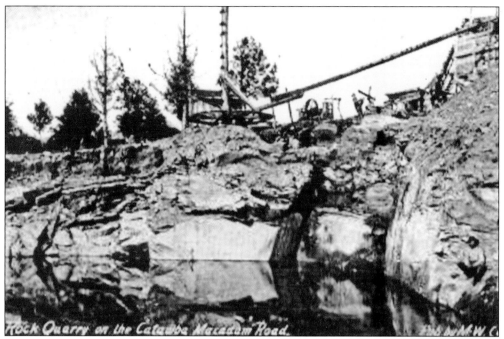

A rock quarry was located near the road and the river in Iredell County to supply materials for the roadway. Road builders may have selected the location of the roadway because of its proximity to the large supply of raw materials. Later the same quarry would be the source of riprap to stabilize the shoreline of the largest manmade lake in North Carolina. (Courtesy of Stallings-Sigmon Collection.)

Evidence of the quarry can be seen today at Duke Energy's Pnnacle Access Area near the bridge crossing Lake Norman between Iredell and Catawba Counties. The public boat landing offers people the opportunity to launch their boats and in the early days made a perfect sunning spot.

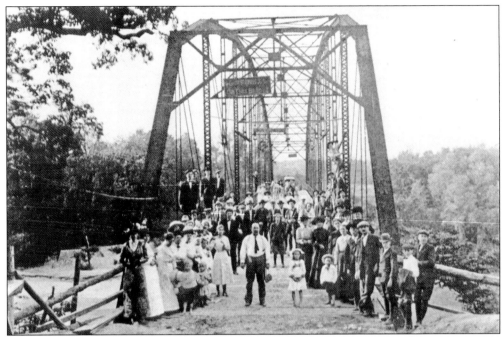

In 1907, two men from Mooresville, B. A. Troutman and James Brown, financed the construction of the heaviest steel bridge in North Carolina. Construction of the bridge began on the Iredell County side in 1907 and ended with a celebration, picnic, and good roads meeting in 1910. Good road boosters from Mooresville traveled the seven-mile macadam road to the river's edge. They celebrated the completion of the bridge and the new connection with Catawba, Lincoln, and Gaston markets and communities. (Courtesy of Pearl Troutman Alexander.)

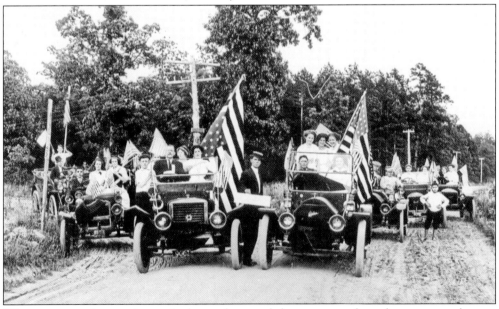

When motorcars became increasingly popular, people began to travel to other towns on the new roads. In Iredell County, citizens lobbied for good roads that would bring business and industry to towns like Statesville and Mooresville. (Courtesy of Connie Sykes.)

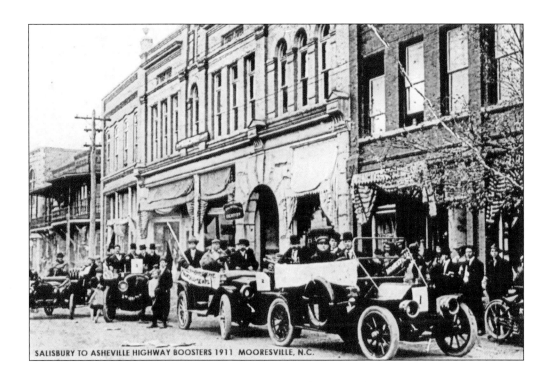

SALISBURY TO ASHEVILLE HIGHWAY BOOSTERS 1911 MOORESVILLE, N.C.

Boosters worked to convince officials that the best route for the Central Highway was through Mooresville, since a direct connection to Catawba County and points west ran through town. Boasting "the best way to anywhere is by Mooresville," citizens participated in parades and events to promote the town's connection with the river crossing and Catawba, Lincoln, and Gaston Counties. (Above courtesy of Connie Sykes; below courtesy of Edward Kipka Collection.)

In July 1916, after several days and nights of continuous rain, the Catawba and Yadkin Rivers and all of the tributary streams rose to such heights that the phenomenon is remembered as the Flood of 1916. The Catawba River, with only one dam at Lookout Shoals, made a clean sweep of all railroad and highway bridges that crossed it. *Mooresville Enterprise* editor Harry Deaton described the deluge as "little less than a calamity" for farmers, business owners, and citizens, estimating the damages and loss of property at more than several million dollars. People living in Iredell, Catawba, Mecklenburg and Lincoln Counties gathered at the river to watch the rushing water. They saw the stream swell from 24 feet to 58.4 feet in less than 24 hours, leaving backwater pools in cornfields and bottomlands when the water receded. (Courtesy of Penny Setzer Christie.)

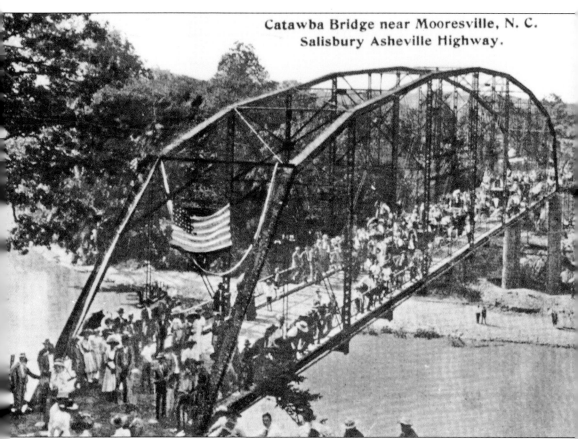

The Buffalo Shoals Bridge and the Mooresville toll bridge across the Catawba River were swept away. The water was 1.5 feet above the height of the bridge (44.5 feet above the normal high water mark), and a barn and debris struck the bridge and carried the wreckage down the river. As it washed away, so did the link between the counties. (Courtesy of Pearl Troutman Alexander.)

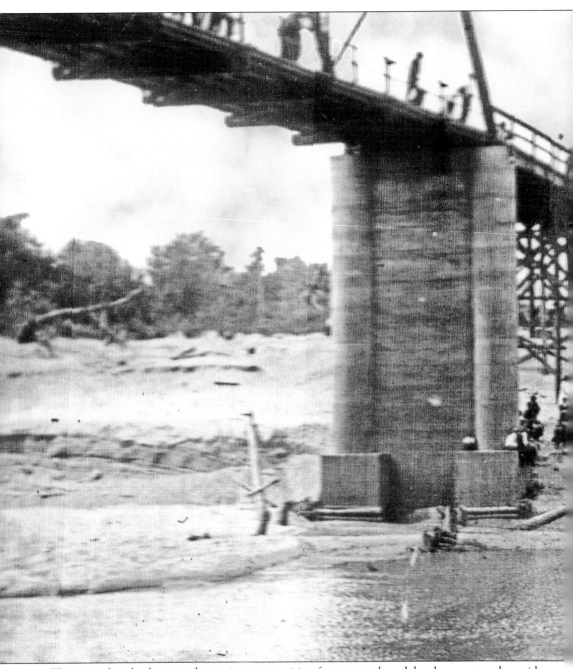

This marvelous bridge served to unite communities, foster growth and development, and provide a site for family and church outings for three years. Troutman and Brown did not rebuild their bridge. The Southern Power Company plants, including the Lookout Shoals facility built in 1915, were damaged, and electric power was cut off. In Mooresville, everything that ran by electric power was at a standstill. Only minimal power was supplied for limited lighting and pumping water. *Mooresville Enterprise* editor Harry Deaton described the west pillar of the bridge as intact and "as good as it ever was" and the Iredell pillars as having iron works twisted around the structures. Loss of the Mooresville and Buffalo Shoals bridges left Iredell residents without

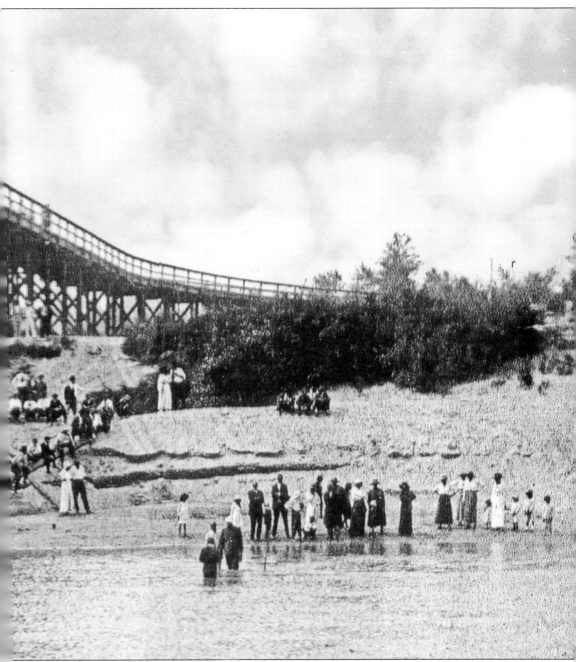

crossings. Capt. C. L. Murdock reported that the bridge over Davidson Creek at W. M. Reinhardt's was unsafe and condemned, while the McPherson Mill crossing was intact and safe. The Monbo Cotton Mill on the Catawba side was washed away along with a warehouse and general store. The Long Island mill was submerged to the roof, while homes and crops were lost completely. Repairs were slow but steady. Power plants came back to life. Bridges were rebuilt for traffic and railroads, and commerce resumed among towns around the Catawba River. (Courtesy of the Edward Kipka family, photograph by Frank Freeze, the *Mooresville Enterprise*.)

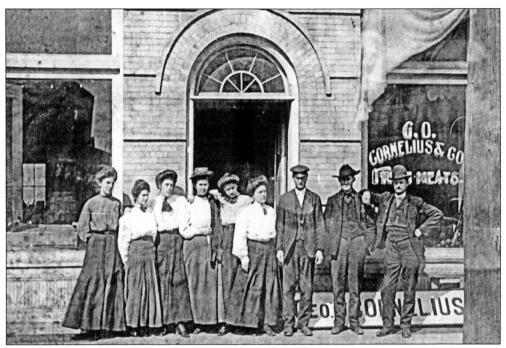

Merchants like G. O. Cornelius, the Farmers' Warehouse, Cooperative Creamery, Sherrill Tobacco Company, and Terrell Country Store resumed business slowly. Ferries came back into service, carrying motorcars, people, and wagons from shore to shore. (Courtesy of Edward Kipka Collection.)

The greatest single loss of property was that of Southern Railway Company, since the total loss to the company because of storm damage during the month of July is estimated at approximately $1.25 million, without taking into account the loss of traffic and the cost of detouring trains. At the Mooresville Depot, the power was out, and station workers provided signals to the few trains coming through. Commerce slowed to a crawl because of the destruction of tracks and bridges. (Courtesy of *The Floods of July 1916: How the Southern Railway Met an Emergency* by Southern Railway Company, printed by the Overmountain Press.)

Two

Harnessing the Catawba River

James Buchanan "Buck" Duke was a man with a plan. In fact, his plans and ideas mechanized the tobacco industry and brought Duke's crosscut and cameo tobacco to the American people. Duke observed the growing war over electricity first hand in New York. By 1880, Thomas Edison, George Westinghouse, and Nicola Tesla were developing ways to electrify the nation, from light bulbs to power stations. Their war over direct current (DC) versus alternating current (AC) ended when Westinghouse was awarded the contract for the Niagara Falls power stations. Alternating current systems could transmit the electricity over long distances to industries, homes, and businesses. Duke, already invested in southern textile mills, saw a way to bring prosperity to the Carolinas using hydroelectric power to increase productivity in the mills. The textile industry was growing in the Piedmont, and Duke saw the potential for a chain of power plants pumping a steady stream of electric power to industries dependent on steam power. He and his Southern Power partner, Dr. Gill Wylie, developed the concept of building large hydro stations interconnected with high-voltage transmission lines that could deliver electricity to all parts of the Piedmont Carolinas. (Courtesy of the Duke Endowment.)

On June 6, 1900, Dr. Walker Gill Wylie and his brother, Dr. Robert H. Wylie, incorporated the Catawba Power Company to build the Catawba Hydro Station at India Hook Shoals on the Catawba River near Rock Hill, South Carolina. It began operation on March 30, 1904, providing electricity to the Victoria Cotton Mill to run its 300-horsepower motor. Wylie shared Duke's view that the South was a sleeping industrial region that needed an electrical boost. On April 30, 1904, the Dukes and the Wylies, along with engineer William States Lee, joined forces and organized the Southern Power Company to draw power from the Catawba River, calling it the "most electrified river in the country." Their goal was to encourage the growth of existing mills and the development of complex industrial operations. With dams and hydro stations came a vast network of transmission lines (355 miles by 1909) to carry electricity to homes and businesses throughout North and South Carolina. Southern Power, incorporated in New Jersey and capitalized at $7.5 million, was the holding company for Duke and Wylie's power assets, which at that time included land, power stations, and manufacturing facilities. In 1910, with a solid customer base, the company created a subsidiary, Mill Power Supply Company, to purchase, manufacture, and sell various types of electrical equipment. (From the Duke Endowment.)

──────── DUKE POWER COMPANY ────────
SOUTHERN PUBLIC UTILITIES CO. AND OTHER ALLIED INTERESTS

AN INVITATION
Would you care to visit a number of typical factories in this section? Plants making products similar to yours? Just let us know when you would like to come, and the types of operations you want to see. We shall be glad to help arrange such a visit for you in every way possible.

PIEDMONT INDUSTRY CAROLINAS

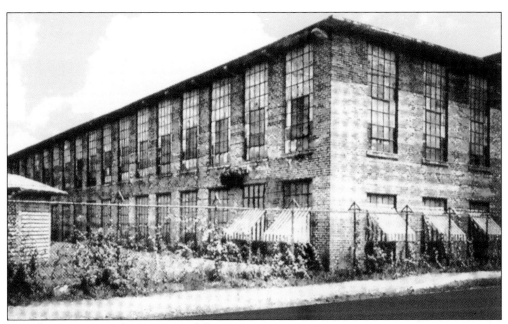

Providing power was the easy part of the plan. Fear of electricity was widespread thanks to headlines about legal executions in the electric chair. Mill owners' fears were put to rest gradually with examples of success and the promise of financial backing from the Dukes. James W. Cannon used the support of Southern Power Company to build his textile complex in Kannapolis, North Carolina. Joe Maynor, in his book *Duke Power: The First 75 Years*, described the plan "to marry the cotton fields to the 'white coal' that flowed through the streams and rivers of the Piedmont." James B. Duke was no stranger to marketing. His tobacco company devoted 20 percent of gross sales ($80,000) to advertising in 1889. Duke Power Company's effort to sell electricity included advertising to potential mill owners and manufacturers and the development and sale of consumer products to people living in newly electrified communities. Employees sold their first product, an electric iron, door-to-door. (Courtesy of Burlington Industries.)

Gone were the days of waterpower supplying individual mills. Southern Power Company transmission lines were distributing electricity to mills, businesses, and a growing number of homes. (Courtesy of Stallings-Sigmon Collection.)

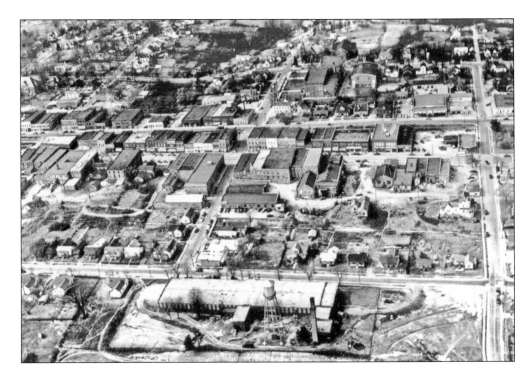

The Mooresville Cotton Mills was one of the first companies to take advantage of the opportunity to increase its production with electricity. By providing electric power to the spindles and weaving machines in its plant, manufacturing levels and efficiency increased. Thanks in part to the new source of power, Mooresville Cotton Mills expanded to employ 2,000 people by 1936. (Courtesy of Stallings-Sigmon Collection.)

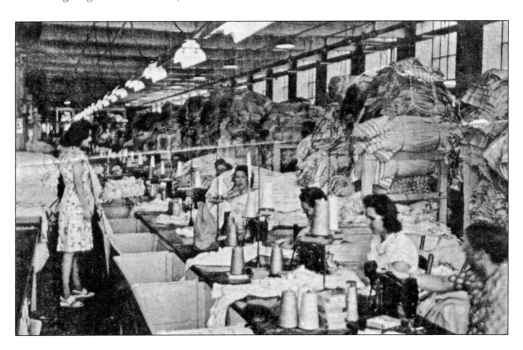

The increasing use of electricity provided by the Southern Power Company (later Duke Power) enabled mills to increase their production. Coal gradually became the second choice of power to run the mills machines. Mooresville Cotton Mills provided right-of-way access through the Mill Village power lines leading to the mill's power plants. Mooresville was only one of the towns in the area to benefit from Duke's support of textile mills. Often a deal was struck to include a mill's community in the power plan. (Courtesy of Stallings-Sigmon Collection.)

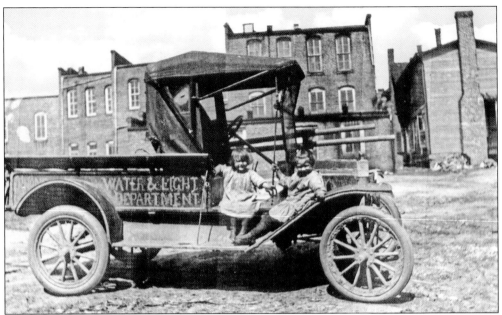

In 1906, Mooresville's 311 voters said, "yes" to a $10,000 bond referendum to build a municipally owned electric system, Municipal Electric Company. The town was electrified using the Southern Power Company system of transmission lines. James Donald was hired as superintendent of the light plant, with a salary of $75 per month. The town's Water and Light Department truck was dispatched to take care of maintenance of these basic services in the community. (Courtesy of Edward Kipka family, photograph by Frank Freeze, the *Mooresville Enterprise*.)

As the town grew, so did the demand for electric power for homes, businesses, and municipal services. The town's Light Committee, headed by P. S. Boyd, recommended that the contract with Southern Power Company should continue, with new poles for the lines installed on the opposite side of the street from the telephone lines. (Courtesy of Edward Kipka family, photograph by Frank Freeze, the *Mooresville Enterprise*.)

Electric lights were installed in a growing number of homes, businesses, and churches, like the Associated Reformed Presbyterian. People began to discover that this invisible power called electricity was safe and useful. In 1908, the Light Committee installed lights and fixtures in a large tent on Broad Street for a moving picture show. The movie owners paid $40 for the power. According to Roy Troutman, "When the picture show started, the lights all over town would dim. Mechanical pianos furnished the music to go along with the silent film." (Courtesy of the Edward Kipka family.)

Merchants installed a "white way" to light the downtown business district. Designed by Duke Power, the lights paved the way for evening shopping and activities. (Courtesy of Stallings-Sigmon Collection.)

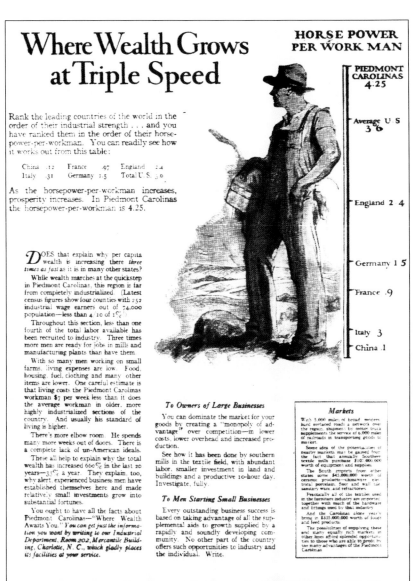

In 1899, even before the Duke brothers joined forces with Dr. Gill Wylie, they organized the American Development Company to acquire water and land rights on the Catawba River in South Carolina's Chester, Lancaster, and Fairfield Counties. This effort laid the groundwork for the construction of 11 dams that would harness river power along 228 miles in North and South Carolina. By 1928, upon completion of the Oxford Dam and Station, 10 dams and 12 powerhouses were producing 1.2 billion kilowatt hours for Duke Power Company customers. An advertisement in industry magazine *The World's Work* in 1927 promotes the Piedmont as a place where "wealth grows at triple speed" thanks to the availability of electric power. Duke Power Company invited owners of large businesses to consider expansion in the Piedmont, where "alert, experienced businessmen have established themselves here and made relatively small investments grow into substantial fortunes." (Courtesy of Stallings-Sigmon Collection.)

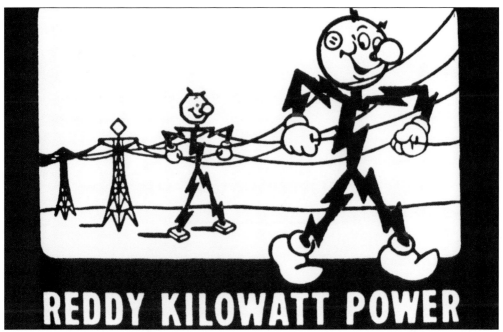

Reddy Kilowatt was licensed in 1926 to power companies across the United States to represent electricity as a safe and useful utility. Designed by Ashton B. Collins of the Alabama Power Company, Reddy was used by more than 200 different investor-owned power companies at one time. Collins refused to allow electric cooperatives to use Reddy Kilowatt as their spokescharacter because he believed they were being socialistic by using money borrowed from the federal government. Duke Power used Reddy to market electric appliances and services through recipe books, pins, kitchen utensils, billboards, bill inserts, and light switch covers. Electric trains and toys became a must-have item under the Christmas tree. This advancing technology appealed to even the youngest family members who were growing up in electrified homes. (Courtesy of Stallings-Sigmon Collection.)

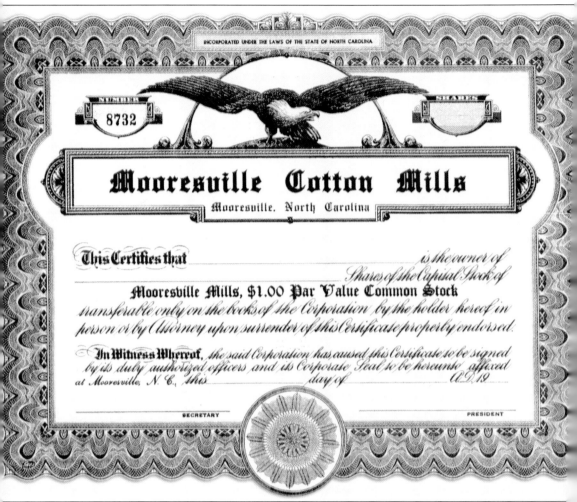

Duke's investment in electricity was not limited to the Southern Power Company. He planned to change the face of the industry by beginning a revolution of industrial growth dependent on hydroelectric power. Not only would he bring electricity to the Piedmont, he and his brother Benjamin also would bring the textile factories and other industries that would buy the electricity, beginning an industrial revolution in the area with Duke power as its indispensable base. He and Benjamin made countless investments in new and existing textile mills, offering the financial backing of the mighty American Tobacco Company to any mill owner who would buy power. Many of them became customers, their mills and plants prospering with the efficiencies made possible by electrified spindles and machines. Duke interests would sell stock and buy more in other companies to keep the expansionary cycle rolling. By this method, the Dukes were responsible in large part for a surge in Piedmont textiles, where by the early 1920s, fully one-sixth of all American spindles were powered by Duke generators. Duke Power Company supplied electricity to about 300 cotton mills, making the Carolinas' textile industry a rival of Massachusetts for national leadership. (Courtesy of Burlington Industries.)

The idea for Lake Norman began in the minds of Dr. Gill Wylie and William States Lee before 1900. Buck and Benjamin Duke were interested in the Catawba River as a way to revitalize Southern industry. The 238-mile stream emerging from its source near Mount Mitchell in the Blue Ridge wound its way east and south through communities like Hickory and Long Island, wide and deep in some places and narrow enough for a ford in others. They envisioned hydro plants supplying energy to textile and other manufacturers in the Piedmont region of North and South Carolina. The Catawba Station became the foundation for a system of large hydro stations sending power through high transmission lines to mills and communities throughout the region. (Courtesy of Duke Energy.)

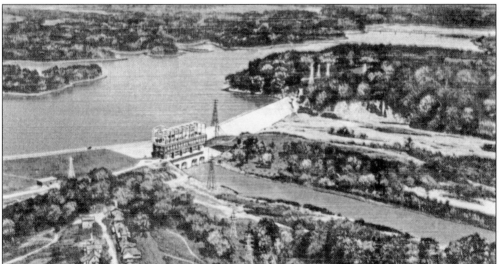

William States Lee Jr. designed 32 hydroelectric stations and 7 steam stations during his career. He transformed the Catawba River into a string of hydroelectric plants 238 miles in length, making him the first engineer to successfully transmit power by wire over long distances. He is said to have surveyed every yard of the Catawba River and made his plans for the power system without much thought to the financing. Buck Duke and Gill Wylie backed up their confidence with cash, and Lee's plan formed the basis of the Southern Power Company. (Courtesy of Stallings-Sigmon Collection.)

Southern Power Company was formed in 1904 and work began to put William S. Lee's plan into action. Lookout Shoals was built in 1915, with Lake James under construction in 1916. Three dams were built to impound the reservoir. Bulldozers, cranes, and workers cleared land for the dams and lakes. Each station was designed to be part of the comprehensive plan for development of the river basin to provide economical power to the surrounding area. Norman Atwater Cocke began his career with Duke in 1906 watching coal and water turn into electricity and fostering the industrial rejuvenation of the South. According to Joe Maynor in *Duke Power: The First 75 Years*, Cocke was among the energy pioneers who both guided and watched "the most fantastic advancements of science in the history of mankind." Cocke retired as president in 1958. Lake Norman is named in his honor. (Courtesy of Duke Energy.)

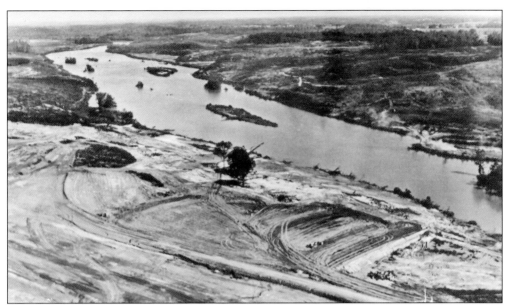

Work at Cowans Ford began on September 29, 1959, with the first rock blasted from the riverbed by Gov. Luther Hodges. When the Cowans Ford site was cleared in April 1960, actual construction began with the erection of a cofferdam to divert the flow of water away from the future dam site. When the cofferdam was in place, the actual construction area was pumped dry. Rock was blasted from the riverbed down to the level of the dam's foundation. Duke Power used the crushed rock and sand from the river to mix with cement, fly ash from a steam plant, and water to make the concrete used in the dam. A steel trestle was built to stretch from one bank to the other to support trains carrying buckets of concrete to the location of the work. Large cranes on top of the trestle lifted buckets from the railroad cars and lowered them into position to pour concrete into the dam structure. The first bucket of cement was placed by Duke president W. B. McGuire on September 1, 1960. (Courtesy of Duke Energy.)

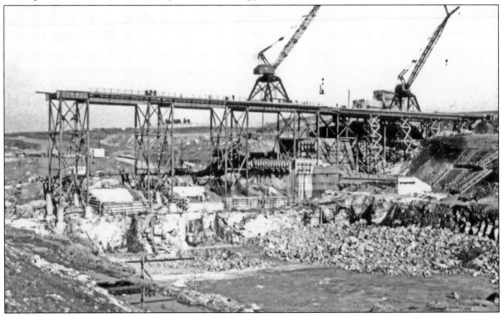

The waters of Lake Norman were planned to fill the riverbanks and cover the Highway 150 bridge with five feet of water. While the dam was under construction and the land was being cleared, a new bridge was built 100 feet north of the old structure in the general location of the Mooresville Bridge, opened in 1911. The $1.2-million structure was 33 feet higher than the old road surface. (Courtesy of Stallings-Sigmon Collection.)

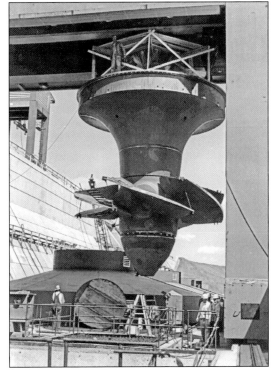

Mammoth turbines were installed in Cowans Ford to generate electricity from the flow of water. Water wheels are connected directly to vertical generators to provide energy to citizens and industries throughout the Catawba River service area. (Courtesy of Duke Energy.)

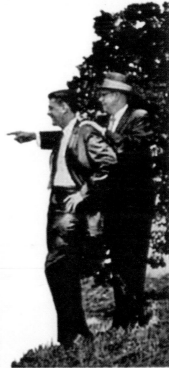

Duke Power Company continued their aggressive marketing program with advertisements promoting the Piedmont region. (Courtesy of Stallings-Sigmon Collection.)

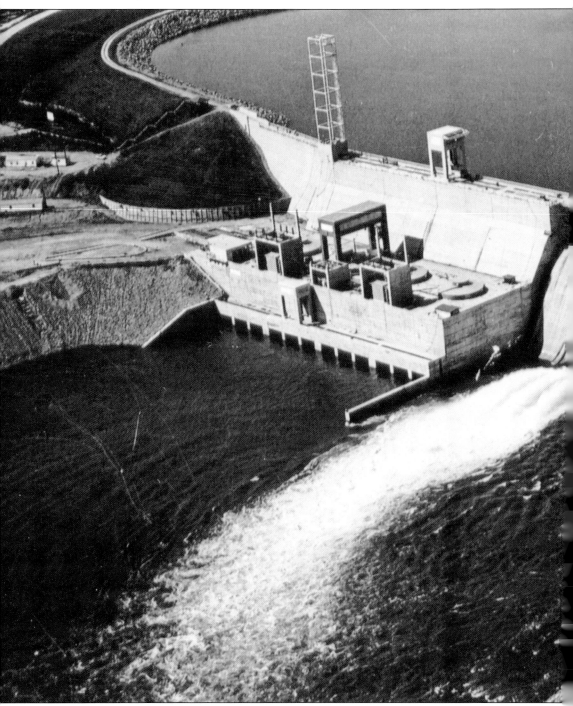

The Cowan Ford Hydro Electric Station was completed in 1963, the last link in the chain of stations and dams on the Catawba River. The total length of the facility is 7,387 feet, including more than one mile of earthen dam. The concrete portion of the dam is 1,279 feet long and 130 feet high. Lake Norman is called an "inland sea," with 520 miles of shoreline and a surface area of more than 32,475 acres. Named after former Duke Power president Norman Cocke,

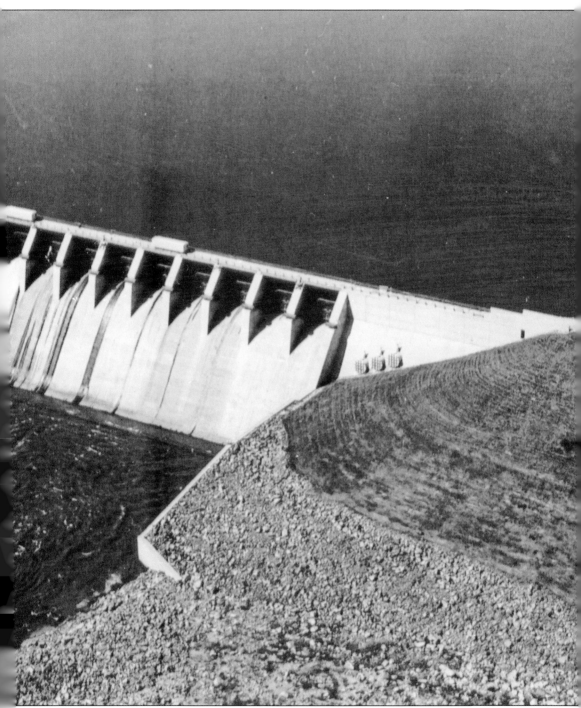

Lake Norman is nearly as large as the other 10 lakes on the Catawba River combined. Full pond elevation at Lake Norman is 760 feet. The water of Lake Norman is used in two ways to provide electricity to the Piedmont Carolinas. The lake provides a dependable supply of water to Lincoln, Davidson, Mooresville, Charlotte-Mecklenburg and Huntersville County in North Carolina. (Courtesy of Duke Energy.)

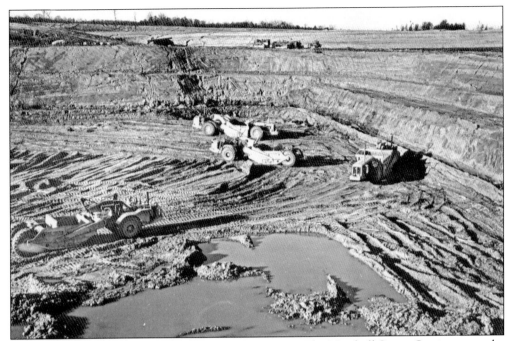

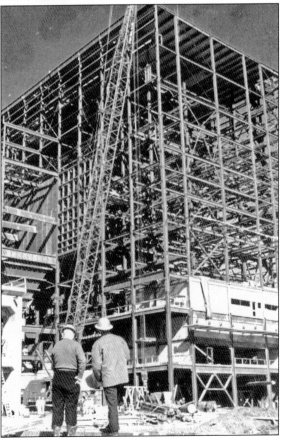

The Marshall Steam Station, started in 1965, was to be the first of three coal-fired steam plants on Lake Norman. It was Duke Power's first billion-dollar station, providing 2,800 million kilowatts of power. The station came on line in 1965 and has been one of the most efficient stations of its kind in the nation since then. Since producing its first electricity in March 1965, station employees have kept the Marshall station among the nation's leaders in efficient power production. Marshall was the most efficient plants in the nation for its first nine years running and has been at or near the top every year since. (Courtesy of Duke Energy.)

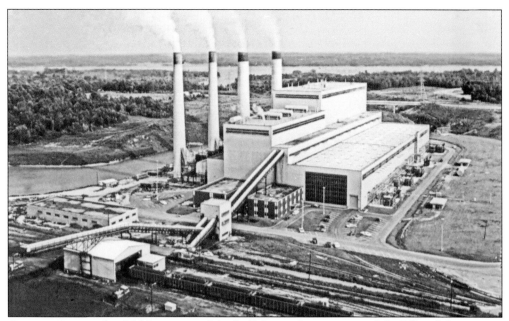

Construction on the 2,000-megawatt Marshall Steam Station, named for Edward Carrington Marshall, Duke Power president from 1949 to 1953, began in March 1962. The four units came into service between 1965 and 1969. Today the Marshall station produces more than one of every seven kilowatt-hours of electricity produced by the company. (Courtesy of Duke Energy.)

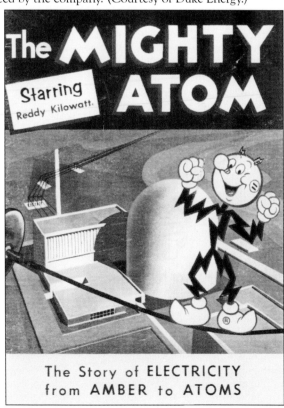

The need for power was growing, and the company was ready to meet the needs. They looked to the new atomic technology to provide efficient power in abundance. Reddy Kilowatt entered the atomic age with comic book–style educational materials for all ages. Everyone needed to be educated on the fundamentals of this new power source. The Southeast's first atomic energy plant was at Parr Shoals in South Carolina. The dedication was attended by governors and dignitaries from North and South Carolina and Virginia plus 1,000 invited guests. The building boom continued, with 18 new industrial plants with an investment of more than $160 million coming to the service area. (Courtesy of Stallings-Sigmon Collection.)

41

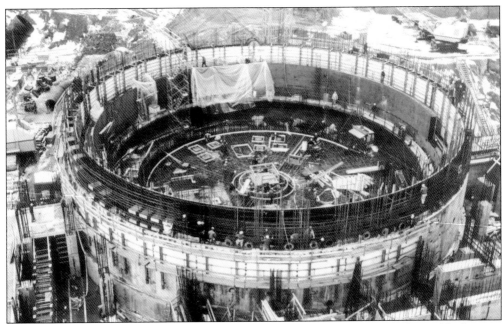

Plans for Duke Power's nuclear station began as early as 1966. The entry into the world of atomic was led by the designer of Cowans Ford, William States Lee III, grandson of the man who envisioned the entire system of dams and power stations. In 1969, plans for a nuclear station at Cowans Ford were announced. By 1976, headlines read "Duke Goes Nuclear," and the inevitable protests began almost immediately. The planned station was to have two units, each capable of producing 1,180 megawatts, about 20 percent of Duke's total yearly generation. Ground was broken for the McGuire Nuclear Station in 1971, with Unit 1 coming on line in 1981. Unit 2 began operation in 1984. There are about 1,250 employees keeping the station working at peak capacity. It was named for William Bulgin McGuire, president of Duke Power from 1959 to 1971. (Courtesy of Duke Energy.)

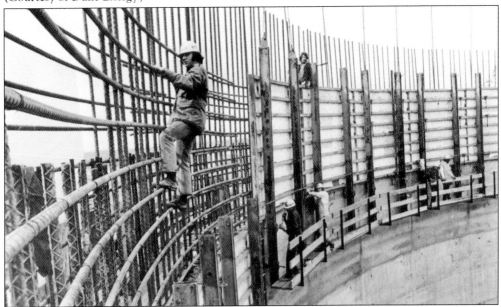

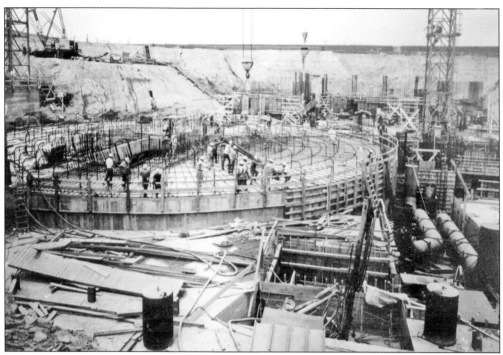

Even though doomsayers predicted dangers with atomic power, Duke proceeded with the development of plants that could produce atomic energy, the "fuel of the future," in its nuclear plants. The McGuire facility at Cowans Ford took shape while regulatory requirements were addressed and employees were trained in operation of the facility. (Courtesy of Duke Energy.)

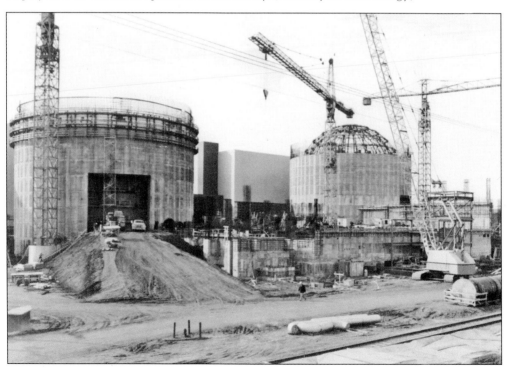

The McGuire Nuclear Station went into operation just in time for a business boom in the Carolinas. Duke addressed public fears of nuclear energy by providing information on how a plant produces energy and how such plants are prepared to meet emergencies. The effect on Lake Norman residents was that they had ready access to inexpensive electricity to run homes and businesses. (Courtesy of Duke Energy.)

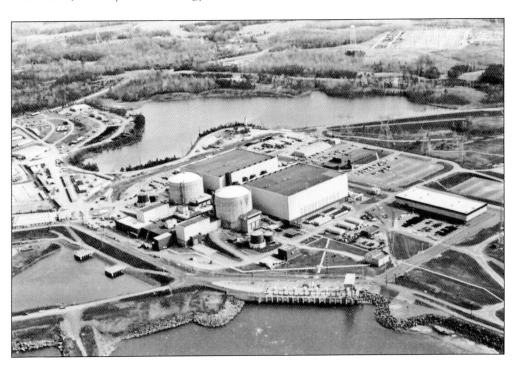

Three
THE PORT CITY OF LAKE NORMAN

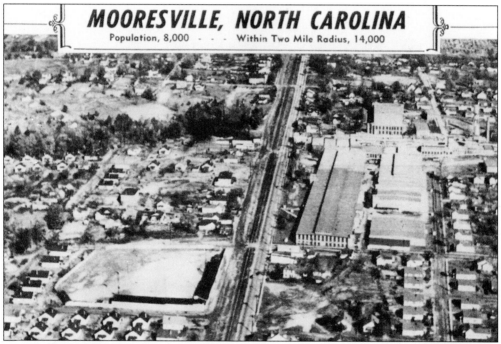

In 1937, Tom McKnight, editor of the *Rounder-News Leader*, rejuvenated the slogan "Queen of Iredell" to describe the town of Mooresville. He wrote, "The descendents of the Scotch-Irish who settled this area do not confuse rhetorical slogans with tangible progress." According to McKnight, "Mooresville is a charmingly social, vigorously industrial and soundly built community which is making steady progress and where living conditions are of the best kind." The town was indeed a leader in Iredell County, working for good roads, modern homes, and dynamic business and industry. Guided by the potential opportunities coming with the new lake, McKnight, photographer Fletcher Davis, and others in the Mooresville Chamber of Commerce came to the forefront of development in 1961 when Tom McKnight dubbed Mooresville the "Port City of Lake Norman" because of its proximity to the shores of the new Duke Power Company reservoir, first called Cowans Ford Lake. Dozens of businesses, civic groups, and organizations took one of the names associated with the new recreational mecca. (Courtesy of Stallings-Sigmon Collection.)

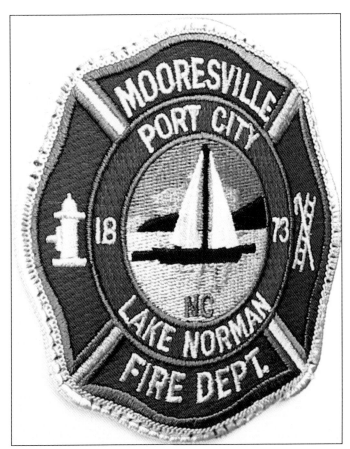

The "Port City" became the name of choice for new businesses working to serve Lake Dwellers. Even the Town of Mooresville adopted the description and began to use the recreational symbol as part of the logo for its fire and police department uniforms.

Mooresville's Main Street got ready for new customers with an eye toward the modernization of its business district. (Courtesy of Stallings-Sigmon Collection.)

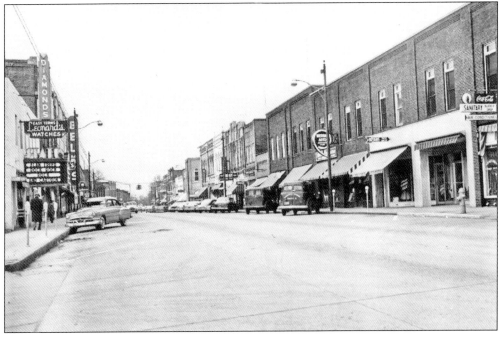

Photographer and artist Fletcher Davis designed the Port City logo and proposed its use as the Mooresville corporate seal. Some people suggested a name change for the town to Lake Norman. Both proposals failed, but the slogan and Mooresville's connection with the new lake grew popular. Promotional materials blended the moor and sailboat images into the visual brand of Mooresville. Mooresville retained its moor brand while taking steps to include the growing Lake Norman region into its marketing and information materials. (Courtesy of Stallings-Sigmon Collection.)

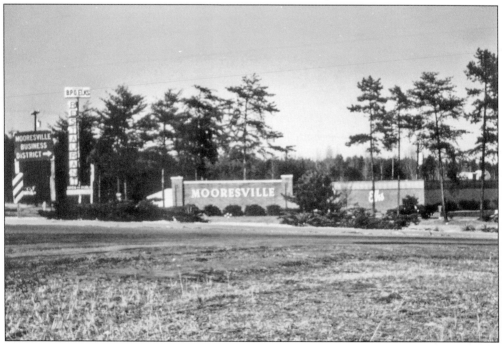

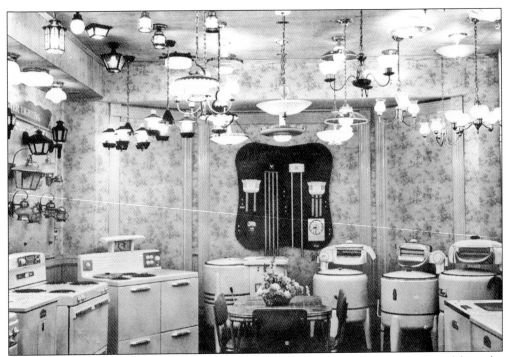

Mooresville had amenities and promoted them to the new visitors on their way to and from the lake. Supermarkets, restaurants, department stores, churches, and service stations provided some of the comforts of home to Lake Dwellers. Mooresville merchants considered themselves steps away from Lake Norman and the most convenient place to shop. Stevens Company provided goods and services. (Courtesy of Stallings-Sigmon Collection)

John Mack and Son offered a wide variety of clothing and accessories for men and women. (Courtesy of S. Mitchell Mack Sr.)

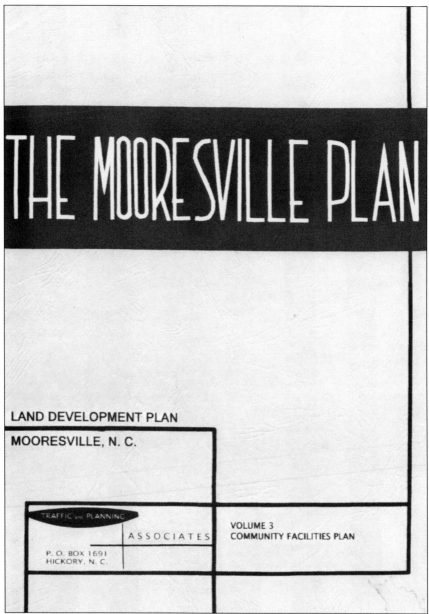

Mooresville was not only convenient—it was modern. A revolutionary idea designed to stimulate business for downtown Mooresville merchants was developed in 1957. City Manager R. T. Nichol described the Mooresville Plan to include closing Main Street to vehicular traffic and remodeling the street into a mall, complete with trees, small park areas, and benches. The entire plan was developed around the new off-street parking lots. The Mooresville Plan was adopted by the Mooresville Woman's Club and the Junior Civic League as part of its annual program of community development and improvement. Longtime participants in the Sears Roebuck Homes and Neighborhood Development Sponsors (HANDS) program, the organizations joined merchants and worked with town leaders to develop a plan for a new downtown area. With a pedestrian mall as its centerpiece, the plan called for modernization of buildings with aluminum and steel and installation of canopies over sidewalks. (Courtesy of Stallings-Sigmon Collection.)

The original plan called for two blocks in the downtown business district to be closed to vehicular traffic and developed into a pedestrian mall. The town manager declared that "a motorist isn't a shopper until he becomes a pedestrian!" That belief formed the foundation of the Mooresville Plan's focus on a traffic-free zone or pedestrian mall for the downtown business district. (Courtesy of Stallings-Sigmon Collection.)

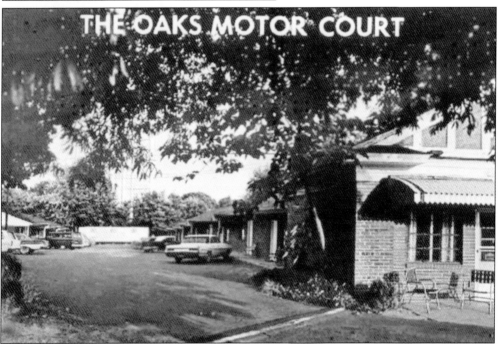

The woman's club took a giant step toward improving the community by selling property donated to it by Lutelle Sherrill Williams so that a modern motel, the Oaks Motor Court, could be built. (Courtesy of Stallings-Sigmon Collection.)

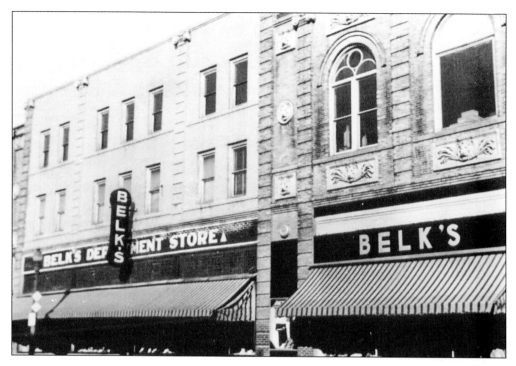

Led by Avery C. Craven, Belk was the first to modernize its store with a new facade and canopies over the sidewalk in front of the store on Main Street. Other merchants followed Belk's lead with facade improvement, but the majority chose to clean-up and fix-up buildings emphasizing the historic architecture. (Courtesy of Francella Craven Kerr.)

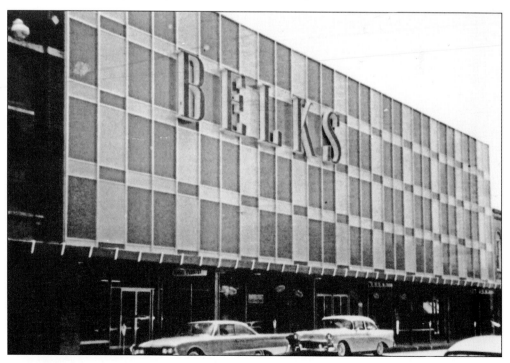

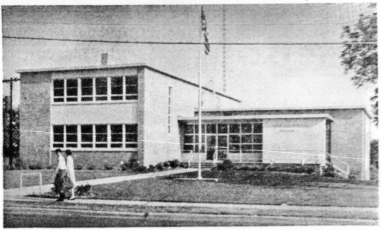

Modern Mooresville was ready for change and growth. Advertisements stated that "Mooresville's attractive new city hall is in harmony with the tempo of progress in the city. Here are centered the modern municipal services which make for pleasant, convenient, modern living. Mooresville is a city with a plan for the future. The widely-publicized 'Mooresville Plan,' providing an ultra-modern and beautifying design for the flow of traffic and new shopping convenience in downtown Mooresville, have been recently activated by constructing new off-street parking areas. This plan is typical of the forward-looking, progressive spirit, which now is propelling Mooresville in a new era of development. Mooresville invites new neighbors, new business, new visitors, and new industries to share and benefit in this progress." (Courtesy of Mooresville–South Iredell Chamber of Commerce, advertisement appeared in the State Magazine.)

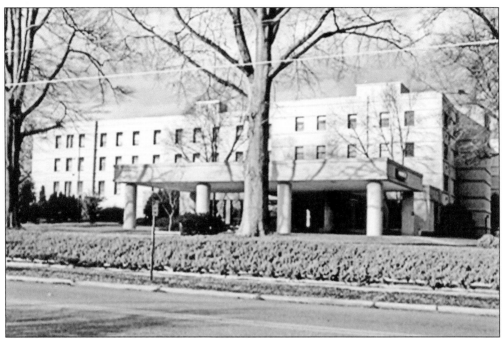

Lowrance Hospital became part of the modernization plan with a new entrance, interior remodeling, and stucco covering the old brick structure. Health services expanded to meet the needs of a growing population of permanent and temporary residents. Physicians and other professionals were attracted to Mooresville's growing population, building modern offices around the hospital to reflect the tempo of the times for the Port City. Lowrance Hospital brought new doctors and expanded its emergency department to treat a wider variety of injuries, many caused by boat propellers, near drowning, and other water-related accidents. (Courtesy of Stallings-Sigmon Collection.)

Mayor Boyce Brawley was an active leader in community development. When Duke Power announced plans for the new lake, Mooresville leaders were the first to consider the opportunities for community recreation. They asked to lease or purchase 200 acres for a recreational facility for the citizens of Mooresville. Even though the Mooresville park did not materialize, the idea set the stage for public access in all areas of the four-county impoundment. Brawley's leadership put Lake Norman recreation at the forefront of Mooresville's development activity. Along with the Mooresville Plan, building a park on Lake Norman was one of the major goals for Brawley's administration. (Courtesy of Stallings-Sigmon Collection.)

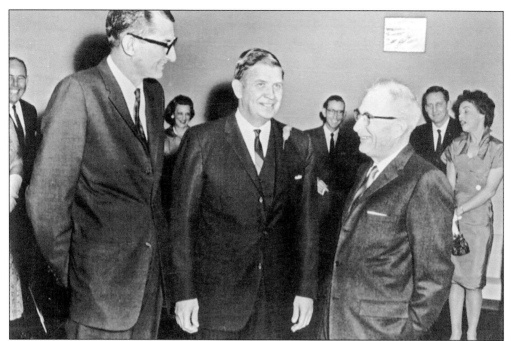

Community leaders like John V. Barger, left, and Dr. Charles. L. Bittinger, right, worked with government officials like Gov. Terry Sanford, center, to bring business, industry, and new citizens to Mooresville. They were among the dignitaries present when Governor Sanford dedicated the Cowans Ford Dam and Lake Norman in 1964. (Courtesy of N. Erskine Smith Jr.)

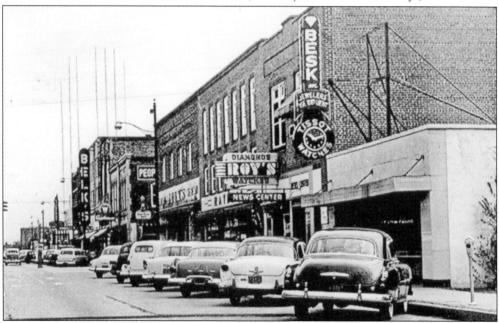

New business like Mills Bootery, Besk Jewelers, and Ellis Kelly's Merle Norman Cosmetics opened to expand the nature and scope of goods and services available in Mooresville. The diversity of downtown businesses included specialty shops, an art gallery at the depot, drive-in dining, and fine clothing for men and women. (Courtesy of Bill Keeter.)

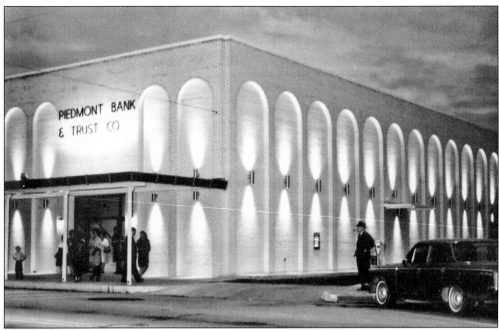

New buildings like Piedmont Bank were both modern and attractive, using the idea of a nighttime "white way" on Main Street. (Courtesy of Chuck Byrd.)

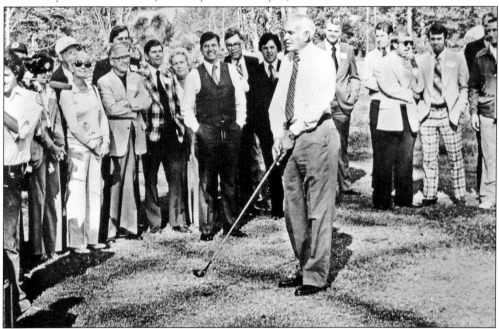

The Mooresville Golf Course expanded its facilities to attract and serve a growing population of permanent and weekend citizens. Burlington Industries worked with Mooresville mayor Joe Knox to donate the nine-hole facility to the town, paving the way for expansion to an 18-hole facility. Tennis, miniature golf, and swimming were available at the War Memorial Recreation Center. Modern buildings housed essential services like banking on Mooresville's Main Street. (Courtesy of Charlie Roberts.)

A colorful brochure, distributed by the Mooresville Chamber of Commerce and Merchants Association, includes pictures of amenities like restaurants, shopping, and recreation areas available to citizens and visitors. Mooresville took on the responsibility of providing goods and public services to the new Lake Norman community. Town facilities were promoted in brochures and advertising materials identifying recreational and business locations convenient to Lake Dwellers. (Courtesy of Stallings-Sigmon Collection.)

Mooresville adopted the mantle of Port City officially with the issue of car tags for residents proclaiming Mooresville as the "Port City of Lake Norman."

Downtown Mooresville grew and changed with the times. New shops opened in old buildings, and other businesses, like the What-a-Burger, replaced buildings like the George C. and Anna W. Goodman home on South Main Street, which housed the Bunch Funeral Home and Sam Ingram's Townhouse Restaurant. (Courtesy of Bill Keeter.)

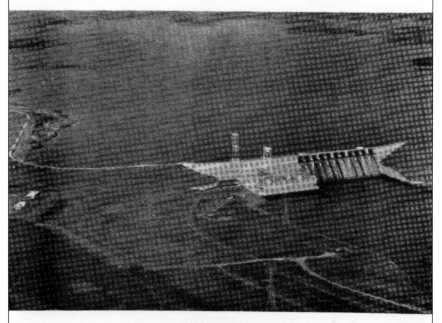

By 1967, Lake Norman was the second home for thousands of residents from local towns like Statesville and Mooresville and regional locations like Winston-Salem and Greensboro. Mooresville's 1967 telephone book featured a photograph of the Cowans Ford Dam and reinforced the connection between the Port City and Lake Norman. (Courtesy of Stallings-Sigmon Collection.)

In 1982, the Mooresville Chamber of Commerce and Merchants Association merged to form the Mooresville–South Iredell Chamber of Commerce (MSI). Banker Steve Robinson was MSI's first president and guided the organization through a time of unprecedented growth and change.

One major change was the adoption of a new logo. The nature of the organization and its image changed from one tied closely to the Mooresville Cotton Mills to a Lake Norman–inspired sailboat theme. (Courtesy of the Mooresville–South Iredell Chamber of Commerce.)

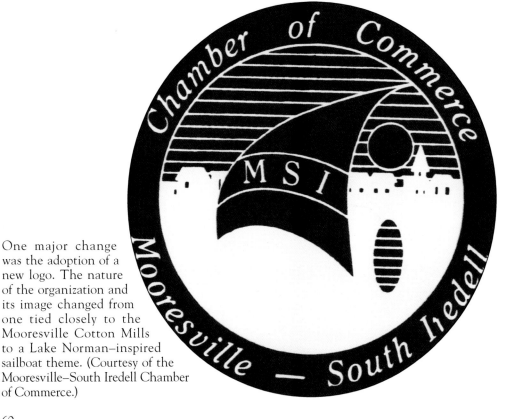

Further refinements in the logo used a more modern boat with a checkered-flag touch of auto racing. The chamber's Internet presence used a visual theme of Lake Norman. Moving into new quarters on Main Street, the chamber added staff and began to focus on emerging economic development needs and opportunities. (Courtesy of the Mooresville–South Iredell Chamber of Commerce.)

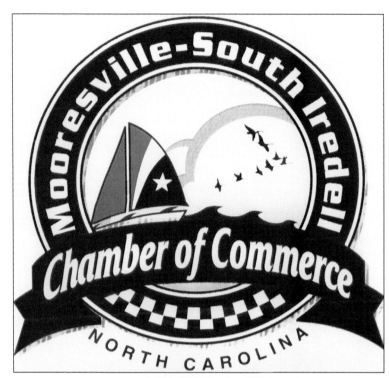

By 1987, downtown Mooresville began to experience a loss of business due to the new big-box stores like Wal-Mart. New strip shopping centers were being built on the outskirts of town, on the Highway 150 Bypass and nearer to Interstate 77 and its Lake Dwellers. Ray Boone, manager of Belk, celebrated its 100th anniversary and prepared to move its operations from downtown.

Duke Power Company purchased the Belk block, including People's Furniture and the space occupied by the State Theatre, to clear the way for a new service center. When plans changed, the vacant property created a large hole in the downtown landscape and the downtown economy. The Mooresville Downtown Commission was organized as part of the North Carolina Main Street Program on May 31, 1988. Director Wayne Frick organized the merchants and developed an aggressive effort to market the downtown business district to shoppers in the region.

Four

Fun at the Pond

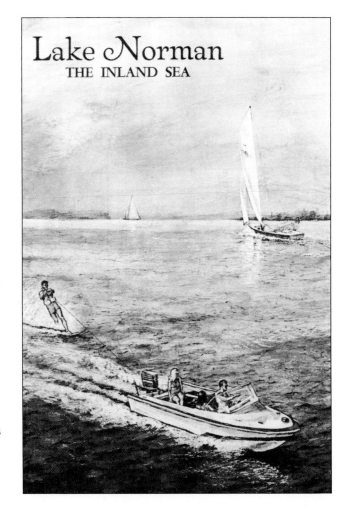

In 1964, the *State Magazine* put the spotlight on Lake Norman in "North Carolina's new and huge Inland Sea." Written by Harry Snook, the article described a liquid community touching the borders of four counties in the Piedmont. "Even with homes, summer cottages, docks and boathouses being constructed by the scores along its shores, Lake Norman appears almost untouched to many observers, it's that big." (Courtesy of Carroll Rempe.)

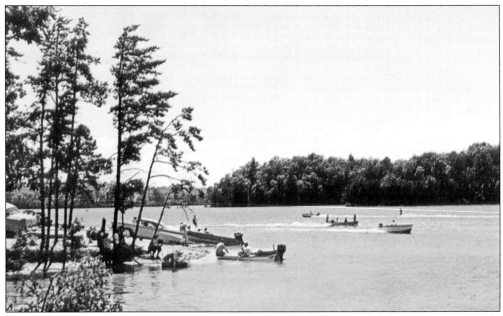

In 1964, Duke Power owned about 50 percent of the lake's shoreline. Duke Power Company made much of the shorelines of its power lakes available for recreation on a leased basis. By 1964, more than 2,600 cottage sites were available, with leases beginning at $120 per year. Duke Power built roads to reach lakeside sites and paid taxes on all the land involved. Private developers, many former farmers, sold and leased lots and established subdivisions with names like Moonlight Bay, Kiser's Island, Catalina Cove, Bonanza, and Island Forest. (Courtesy of Stallings-Sigmon Collection.)

Roads leading to and from the lake became busy with Lake Dwellers. Brawley School Road provided easy access to Mooresville.

Lake Dwellers brought energy and innovation to their claim on the new shoreline. Turning off the highway, they found themselves literally in the woods, where roads were either bad or nonexistent, and creature comforts were back in civilization. Clearing a path to the water was the first challenge, while building shelters and docks were vital to access to the lake. Lots were leased from Duke Power Company. (Above courtesy of Mary Mack Mills Benson; below courtesy the Edward Kipka family.)

Lake Dwellers often took a break from the manual labor to actually enjoy the lake. Pioneers, like Pat Aycoth (left) and Frances Whiteside, enjoyed the lake before returning to their real world homes in Charlotte, Mooresville, Concord, and Statesville. (Below courtesy of Stallings-Sigmon Collection.)

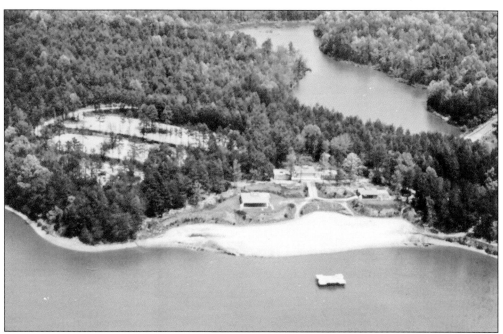

Duke Power's license from the Federal Energy Regulatory Administration included certain public responsibilities related to lake management. One of the most important required Duke to provide public access areas. The company took their responsibility seriously and built 10 access areas with parking lots that could accommodate 30,000 vehicles. Land was leased to private marina owners to provide public boat docks and storage, gasoline, and supplies for boaters. A public park was formed in September 1962 when Duke Power Company donated 1,328 acres of land on the northeastern shore of Lake Norman in Iredell County for a state park. Known as Duke Power State Park, it features a 33-acre constant-level swimming lake impounded by a dam, camping and picnic areas, bathhouse and swimming facilities, and a boat launching ramp. Heavy sand covers the 400-yard beach. (Courtesy of Stallings-Sigmon Collection.)

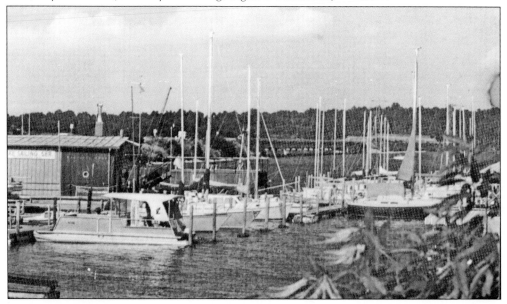

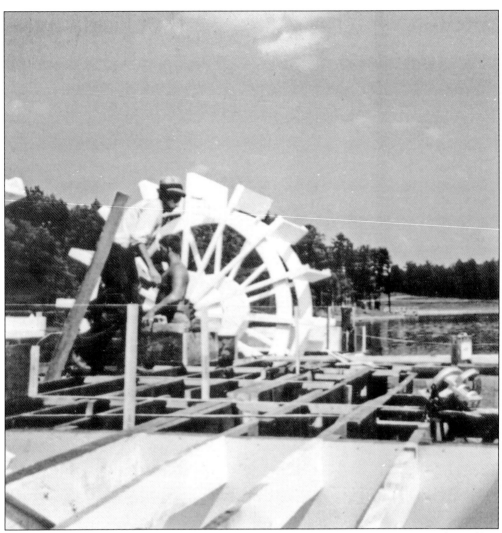

The Doolie community became involved in the excitement of the new lake when Loundes Buffton "Buff" Grier of Statesville set up shop for the construction of an excursion boat. In August 1963, crews began work on a 78-foot long replica of a Mississippi riverboat. The *Robert E. Lee* was a plush boat with 10-foot-high paddlewheels and room inside and out for dining and dancing. The ship took as many as 70 people on tours of the 33,000-acre "inland sea." The hull and diesel engine of the vessel were completed at the Doolie site and then sailed to its berth on Lake Norman's main channel east of Davidson Creek. The docked vessel was visible from the new Interstate 77 causeway connecting Mecklenburg and Iredell Counties. (Courtesy of Stallings-Sigmon Collection.)

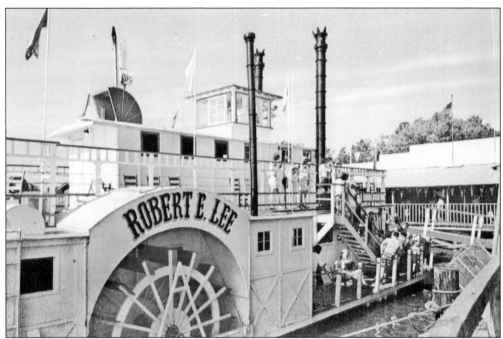

Buff Grier and his workers completed the 75-foot superstructure at the southern site. When the *Robert E. Lee* "put to sea," the flat-bottomed, 27-foot wide, 30-ton vessel drew about 12 inches of water, making travel on the lake safe from shoals. The superstructure covered most of the length of the boat, with two giant smokestacks and a pilothouse. Inside were plush seating and an orchestra pit. The *Robert E. Lee* sailed an east-west route in the widest part of the lake and south toward the Cowans Ford Dam until 1968, when it burned to the waterline at its permanent dock. (Courtesy of Stallings-Sigmon Collection.)

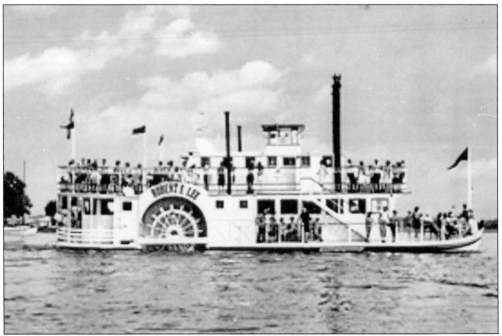

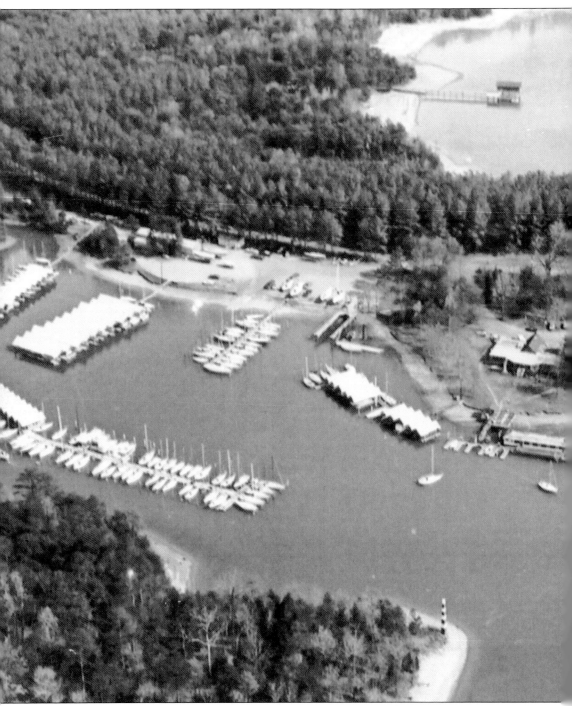

In a 1986 interview, Katherine Teague, owner of Outrigger Harbor, Inc., said, "I remember the first time I saw this place. Buck said the place was just beautiful, and he brought me down here by water to see it. The place was beautiful, a pristine with only water and trees." It wasn't pristine for long. Buck Teague, who died in 1982, leased the 43-acre peninsula off Jetton Road and transformed it into a campground, marina, and entertainment center. The Teagues thought

a few boat slips would be enough, but sailing took off after the gas crunch in the early 1970s. She recalls feeling that "everyone isn't lucky enough to live here. We operate Outrigger Harbor because we believe someone should provide a way for people to enjoy this place. It doesn't just belong to those who got here first." Outrigger Harbor became the largest sailboat marina on the lake, hosting a full schedule of racing.

Earl Teague Jr.'s sailboat, the *ET*, is a winner in the world of Lake Norman sailing. He took over for his father, Buck, and works with his mother operating the marina, campground, and boat sales for S2 Yachts. Outrigger Harbor Sailing Association offers competitive racing throughout the year.

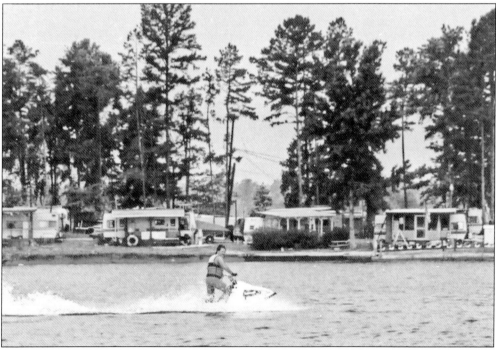

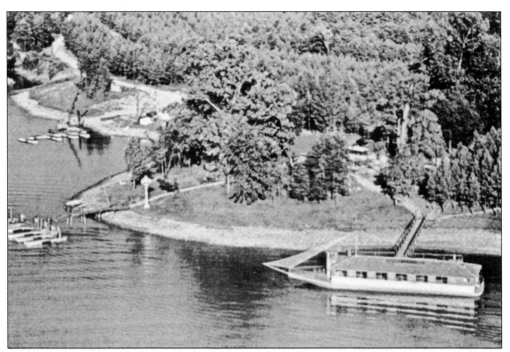

Buck Teague and his Outrigger Harbor had everything for the weekend Lake Dweller, including a real-life Polynesian war canoe fashioned loosely after Thor Heyerdahl's *Kon Tiki*. Teague called his 100-foot excursion boat "a dream come true" in 1965. He told reporters that he had done everything possible to make the South Seas motif convincing. Real palm fronds were used in the dining and dancing area inside, with palm-matted floors and handmade sculptures befitting islands of the South Pacific. The grand opening event hosted newspaper, radio, and television people for a four-hour tour of the Inland Sea, complete with dinner and dancing to live music. Teague completed the Polynesian venue with a building housing offices, a marine and general store, and a large dining and meeting room. As Outrigger Harbor grew into the largest marina on Lake Norman, focus changed to sailing, but the official war canoe of Lake Norman remained at its dock for more than 30 years. (Courtesy of Stallings-Sigmon Collection.)

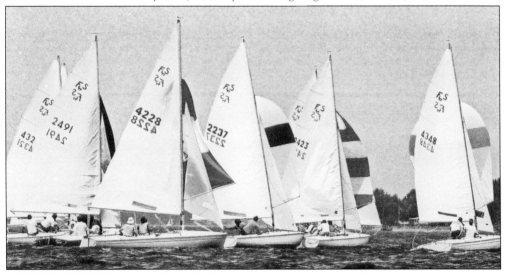

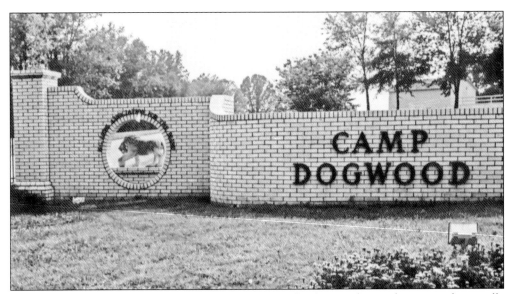

Mooresville Lions Club, chartered in 1939, was active in developing ideas and programs for visually impaired and blind citizens. Shaw Brown, Jim Mack Morrow, and Bill Earnhardt led their fellow Lions in raising money and fostering support of Camp Dogwood through White Cane campaigns. More than $350,000 was raised statewide to begin construction and provide programs at the Lake Norman campus. The idea for a place of recreation that would meet the needs of the visually impaired and blind came from the Lions Club in 1959, when Lion C. Coleman Gates (Burlington Lions Club) developed the idea with the North Carolina Association for the Blind and presented it to the Lions of North Carolina. In 1966, the Lions purchased a 40-acre site on Lake Norman in Iredell County from Clarence and Lolabelle White. Lions Club members got to work to raise money and design a camp with input from visually impaired people and support groups. North Carolina Lions built and continue to support Camp Dogwood with funding from individual clubs and donations to the White Cane program. (Courtesy of the Mooresville Lions Club.)

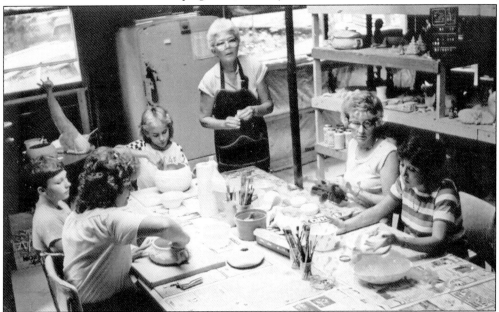

Mooresville Lions were actively involved in the project, and in 1968, the first building was completed. The project was one-of-a-kind, an innovative way to serve blind people by providing a place where they could enjoy themselves freely in outdoor and indoor activities. The camp grew with new dormitories and multi-purpose buildings and outdoor recreational areas for swimming, boating, horseback riding, and water skiing. With the help of sighted counselors, blind campers are able to pilot boats and ride horses along the lakeshore and in trails. Visitors to Camp Dogwood find the sounds of laughter, splashing water, neighing horses, and singing. Nothing like this camp exists anywhere else in the state. (Courtesy of Wayne Frick.)

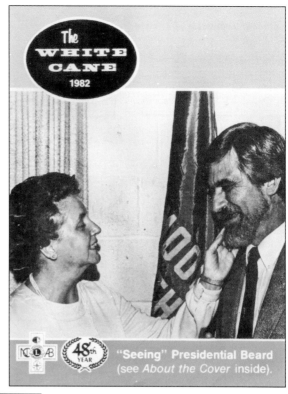

Each summer, campers enjoy the opportunity to play golf thanks to the PGA professionals at the Mooresville Golf Course. Head PGA professional Jeremy Elliot and his first-grade daughter, Bailee, join forces to help VIPs learn to enjoy the game of golf.

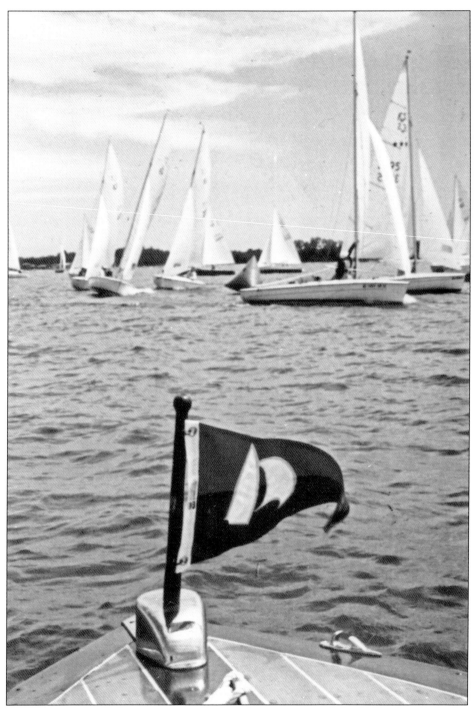

Lake Norman Yacht Club was organized before the water arrived. In 1957, when Duke Power announced plans for construction of Cowan's Ford Dam, eight landlocked sailors led by Stan Livingstone, George Knight, and Louis Klutz organized and developed the concept for a yacht club that would promote class racing. In 1961, Lake Norman Yacht Club was incorporated with 25 charter members.

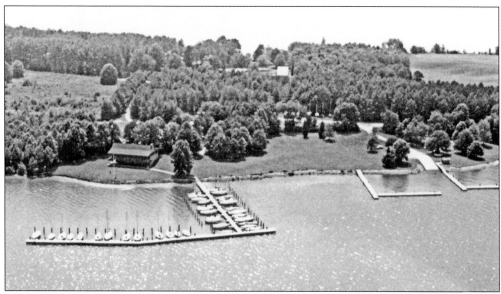

Because of the size of the lake and the location, the hope was that the Lake Norman Yacht Club (LNYC) would develop into "The Inland Yacht Club of the Southeast." Several sites were considered around the lake because they had access to large areas of open water, which would be ideal for laying out a challenging racecourse. Louis Klutz and Curtiss Torrance selected the original site. The facility consisted of a 24-foot-wide and 80-foot-long ramp, a single dock, and a mud road turnaround. As the lake was beginning to fill in early 1963, a small cofferdam was built to keep water back while the ramp was being poured. Lake Norman Yacht Club was the first to bring national sailing competition to Lake Norman. Because of the lake's size, a challenging course could be laid out for any one-design class. In the early days, cabin cruisers were all the rage for power boaters, but the 19-foot daysailor was perfect for inland racing. Among the popular classes at LNYC are Thistles, Y-Flyers, and Highlanders. In 1957, Sandy Douglas designed one of the most enduring and popular daysailors, the Flying Scot. Irmgarde Schildroth bought No. 1, enjoying the boat in spirited races and leisurely cruises on the Inland Sea.

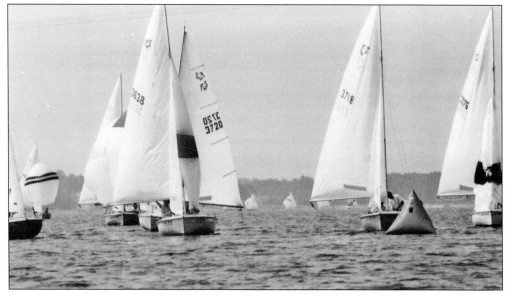

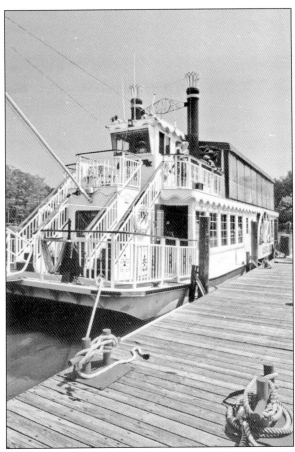

The excursion boat business returned to Lake Norman with Bud Lancaster's *Catawba Queen* in 1981. Similar in style to the *Robert E. Lee*, it featured two decks as well as dining facilities for year-round enjoyment. Adding to the variety of boats on the lake, Jack Stollery of Lincoln County got into the spirit of every occasion with his tugboat replica. No parade or event was complete without the Stollerys' festive vessel.

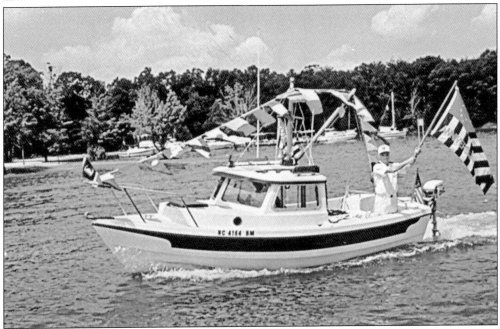

Fishing in Lake Norman was the best available anywhere in the state during the lake's first decade. According to Duke Power, "This is the biological history of such power lakes, and it follows that nature abhors a vacuum." Lake Norman had food in abundance for the fish, such as largemouth bass, crappie, bream, catfish, carp, and threadfin shad. The North Carolina Wildlife Commission allowed residents to fish in the waters of their own county without a license if live bait were used. A North Carolina fishing license cost $4.25 and a county license $1.65 per year. In 1986, the best way to become a real fisherman was to visit Jon Kaigler at Jon's Performance Marine on Highway 73 near Holiday Harbor. The staff provided a complete boater's package, including boat and motor safety, maintenance, and fishing equipment. Staff members will take the customer to the water and show where and how to fish. (Courtesy of Kay Kipka Jones.)

Marinas expanded their services to meet the growing need for boat slips. Holiday Harbor offered covered and open docks as well as boat launching facilities. (Courtesy of the Mooresville–South Iredell Chamber of Commerce.)

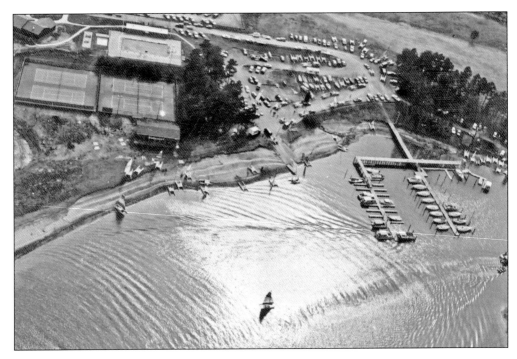

Duke Power Company employees developed Cowans Ford Country Club adjacent to the western arm of the Cowans Ford Dam. Featuring a golf course, swimming pool, tennis courts, and boat docks, it was home to the Hobie fleet. In 1984, the largest regatta was sponsored by Belk department stores. In the 1980s, the marina was removed, and golf holes, pool, and tennis courts were relocated for the development of homesites on the shoreline.

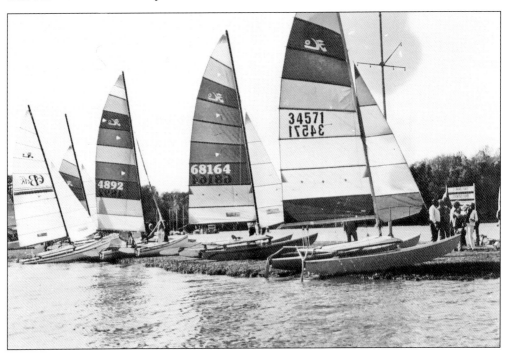

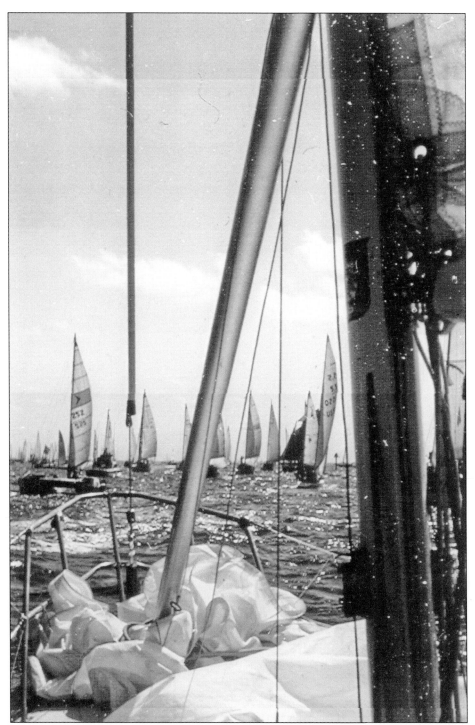

Sailors and boaters of all kinds enjoyed the wide expanse offered by the main channel and Ramsey Creek area near the Cowans Ford Dam and McGuire Nuclear Station. This area of deep water is home, so they say, to "catfish as big as Volkswagens" and other such creatures that call Lake Norman home.

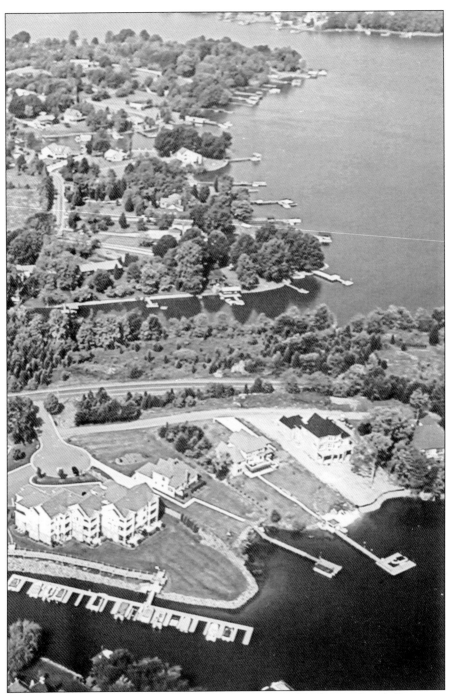

Lake Dwellers of a more permanent kind began to look around for homes. People began to spend more and more time at the lake. Commuting from places like Charlotte, Winston-Salem, and Salisbury was an acceptable price to pay for living at the lake. Soon it was difficult to find a lake lot available for lease. Overnight it seemed everything was for sale. Condos, the first on the Kiser's Island Causeway, offered a grass-free alternative to living in town. Community docks and waterfront provided instant access to the water in the boat moored just steps away.

Lake Norman was just fun. Lake Dwellers of all ages and interests enjoyed a day on the water, in the water, or something in between. Anyone could perfect their skills on skis or at the tiller of a sailboat. The younger generation, personified by Betsey Smithdeal, grew up around boats, marinas, and friends from other places.

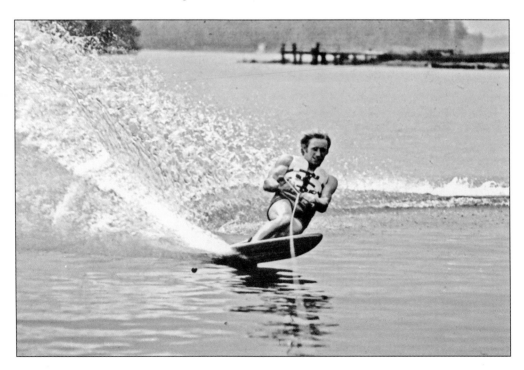

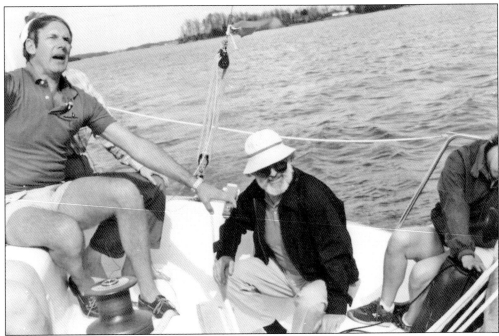

Mike Naramore, charter member of Lake Norman Yacht Club and owner of Anchorage Marine, is a sailor's sailor. Born and raised in Connecticut, he developed his winning skills in one-designs and his latest fast boat, a Pearson 28. Always ready to show Lake Norman to visitors, he entertained WBTV personality Jim Patterson on an excursion. "Uncle" Jim, as he is known to television viewers, took the tiller out of Holiday Harbor marina.

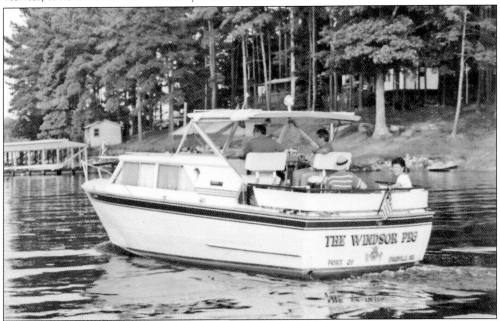

Cruising became popular, and people soon discovered that a cabin cruiser moored at a covered slip at Midway Marina was just as good as a house on the shore—even better, since there was no grass to mow. (Courtesy of Bill Keeter.)

From the upper reaches around Buffalo Shoals to the busy water highway at the Cowans Ford Dam, Lake Dwellers enjoy the world of striped bass, spinnakers, steam, and power to the fullest. Today's Lake Norman is busier that anyone ever imagined. Sailors can catch the unobstructed breeze and sail from Lincoln County to Iredell County. Fishermen can find a quiet cove where the crappies are biting. Skiers can skim the smooth water of their very own slalom course. There is fun to be had in these waters, a kind of enjoyment that is as free as the river. Lake Norman, created to produce power for industries in North and South Carolina, became the Inland Sea. It is a sparkling world for boaters and those who love the splash of a striped bass and the lapping of waves and beautiful sunrises and sunsets. (Postcard courtesy of Stallings-Sigmon Collection.)

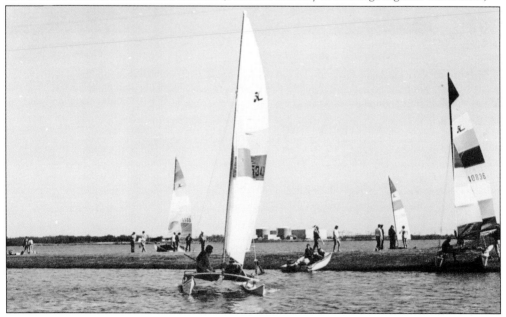

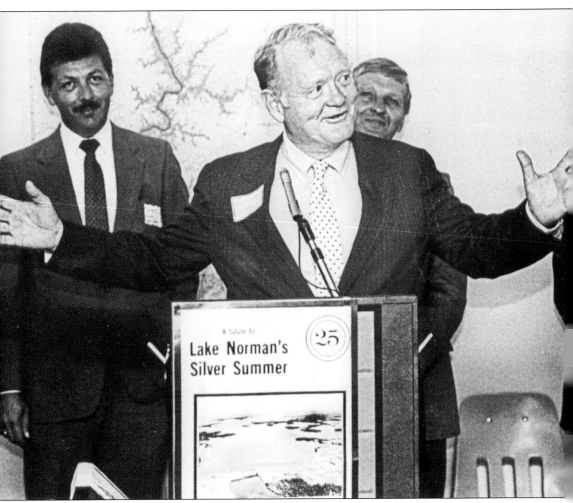

In 1988, Duke Power president Bill Lee was head of a company that had realized its dream in less than a century. His grandfather William States Lee Jr. had the dream of an electrified river and by sharing it with James B. Duke and Dr. Gill Wylie set the stage for his dream to come true. William Lee, designer of the last dam on the Catawba, welcomed all who would come to Lake Norman for a "silver summer" of fun.

Five

WHO'S MINDING THE LAKE?

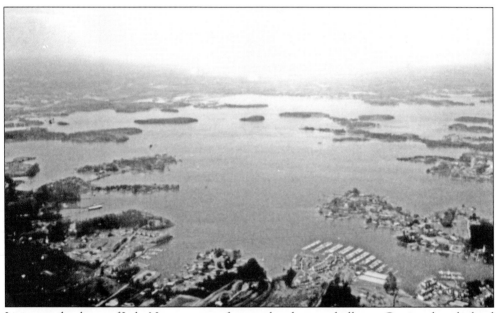

Living on the shores of Lake Norman, even for a weekend, was a challenge. Getting there by land was a large part of the fun. On the water, however, getting there and back could be downright intimidating. An afternoon excursion down to the Cowans Ford Dam could turn into an evening return trip with landmarks obscured by darkness. For more than a few boaters, turning in into the wrong cove could result in grounding on and island or shoal. They could find themselves miles away from home, sometimes in a different county. Safety on the water was not the only concern, but the potential for accidents and injuries brought citizens and county leaders together to make some plans for the new Inland Sea in terms of boating and swimming safety. The issue of safety on the water came to the forefront when a swimmer was struck by a boat and killed in 1965. The Lake Norman Safety Committee held its first meeting on July 19, 1965. Lake Dwellers looked on the meeting with relief and caution, but most agreed that as the population increased on and off the water, something must be done to insure safety with reasonable rules and regulations. Earl Buck Teague said, "Boaters are afraid that the people who make the laws don't know what they're doing." All agreed that flagrant violation of the law wasn't the big problem. It was ignorance of boating courtesy and safety.

Tommy Whiteside remembers a cookout on the new lake. Charlotte Power Squadron and some Coast Guard Auxiliary members were talking about safety on the day of the first boating accident on Lake Norman, he said. That's when boating safety became a priority. Coincidentally, a letter to Lincoln, Iredell, Mecklenburg, and Catawba County commissioners was mailed that day from Iredell commissioner E. E. Boyer asking for a meeting about safety on the lake. U.S. Power Squadron vessels from Charlotte and Winston-Salem became visible throughout the four counties as members became Lake Dwellers.

Members flying the U.S. Power Squadron ensign began to travel the waters in an effort to learn more about the waterway, pass on that knowledge to boating course students, and provide information for the navigational aid project.

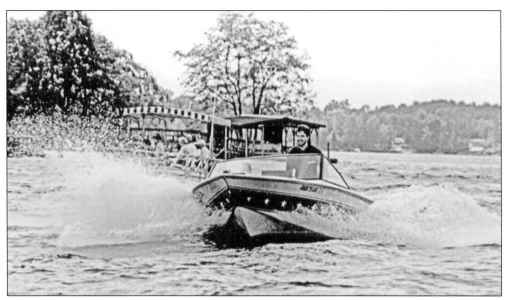

"People who are caught violating boating courtesy should be forced to go to school," said Buck Teague. The safety committee was in agreement that "the whole situation on Lake Norman revolves around education." Charlotte Power Squadron members like Jim Marsden, Elmer Horton, Tommy Whiteside, Charlie Thompson, and Curtiss Torrance were becoming more and more active on Lake Norman, moving some of the boating on Lake Wylie to Lake Norman. There was general anxiety about the state of the lake with regard to what could be done and what should be done to establish priorities and regulations. Buck Teague of Outrigger Harbor said, "On the water, lights were non-existent and even a compass was of limited use." On land, roads ended abruptly at the water's edge, and landmarks like churches were in new locations. Road signs helped for car drivers, but boat operators found themselves with no signs of support. A solution was needed, and one was found through a cooperative effort by the safety committee, civic groups, governments, business people, and North Carolina representative Jim Broyhill. Broyhill sponsored a bill to supplement the North Carolina Boating Safety Act of 1959 and establish the Lake Norman Marine Commission.

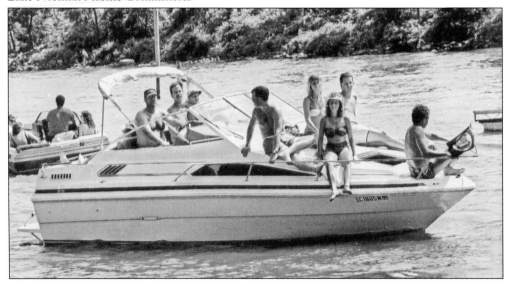

Representatives from the four counties agreed to establish a uniform marking system on the lake in compliance with standard navigational aids on U.S. waterways. Each county provided an equal amount of money to support the work of the commission. First efforts addressed the area of safety on the water and at access areas. With the assistance of Duke Power Company and other businesses and individuals, poles for the markers and lights were installed on the main channel and major creeks. Tommy Whiteside, first commissioner from Mecklenburg County, remembers traveling the main channel to find suitable spots for markers. "We located them near shore and placed them within line of sight from each other," he remembers. The first 20 markers in the main channel were unlighted at first. The work progressed to Mountain, Davidson, and Ramsey Creeks because they were major arteries off the main channel. Whiteside, Elmer Horton, Brooks Lindsey, and others maintained the markers and lights until the 1980s, when the marine commission began work with the Lake Norman Power Squadron to fabricate and install reflective signs and maintain bulbs in the new solar-powered lights.

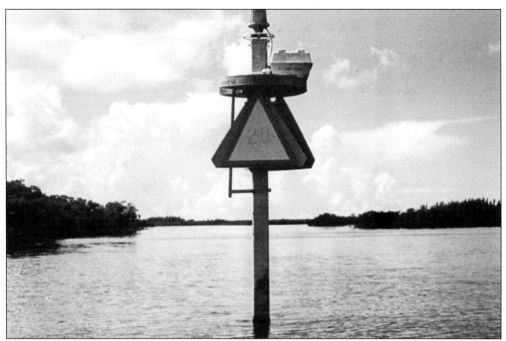

Installing a system of navigational aids is not like installing a stop sign. On land, hazards are visible. On the water, most are just beneath the surface of the water, and the severity of the hazard often depends on the water level. Poles, signs, and lights must be installed and serviced in the water, near shore but certainly not on it. In the early days, lights were powered by batteries or attached to an outlet on shore. Volunteers surveyed the 520-mile shoreline, marking the locations for poles.

Lake Norman Power Squadron members (from left to right) Wayne Whitley, Jim Clark, Rich Williams, Mike O'Connell, Charlie Thompson, and John Krider fabricated large reflective signs for channel and creek markers. Installing the signs required a workboat filled with materials and people to handle the task safely in the often-choppy main channel.

In 1971, Tom Higgins of the *Charlotte Observer* coined the term "reef grief" to describe the state of boating safety on Lake Norman. He applauded the efforts of Bob Hudgins and the Charlotte Power Squadron to provide charts of the entire waterway. Working from soil conservation maps, he traced the contours of the water at full pond and 10 feet down. Duke Power Company provided the topographic information when the water was 20 feet below full pond. Hudgins's insistence on detail led him to travel the entire shoreline and identify shoals and hazards to navigation. Hudgins fell victim to "reef grief" when he ran aground on the foundation of a house that had been torn down in the 1960s. The hazard was included on his chart, named "Robert's Reef." Printed by Jim Brady of Statesville, the chart is the first and only comprehensive navigational chart of Lake Norman. Alexander Cooper studies the chart before leaving the dock.

The 1964 regulations required boat registration for vessels with motors of more than 10 horsepower. Boat operators were required to follow rules-of-the-road safety precautions. All boats were required to have lifesaving flotation devices for each person aboard. The Coast Guard Auxiliary's Lake Norman Flotilla was organized in 1975 with 17 members to offer boating education and vessel safety inspection for boaters. A safety station in the Davidson Creek area offered information and boat inspections within easy access to boaters. Elmer Horton, a charter member, described the auxiliary's patrols as a benefit to Lake Norman boaters. In 1986, the flotilla spent more than 175 hours on patrol, offering search and rescue services in addition to general assistance for boaters.

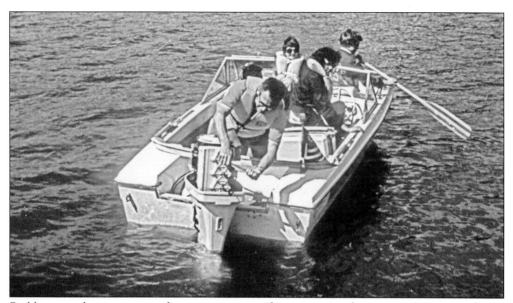

Problems on the water range from running out of gas to getting lost to running aground on a shoal. Boating courses offered by the Coast Guard Auxiliary and the power squadron taught people how to be a safe boater on and off the water. Practical exercises range from planning for a day on the water to navigation to handling emergencies. Both groups offer people a chance to be a better boater through education and awareness.

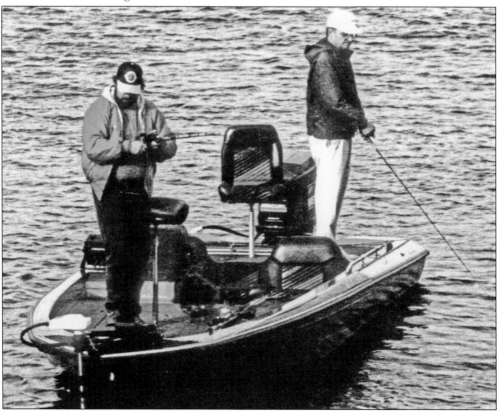

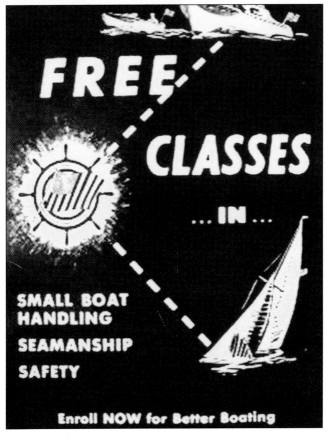

Lake Norman Power Squadron became a reality in 1974. The charter party included Lake Dwellers who were transferred from the Charlotte squadron. In the days since the picnic and talk of safety on Lake Norman, 14 men worked with the safety committee, marine commission, civic groups, government, business, and individuals to make the waterway a safer place for boaters and swimmers. They offered boating classes in the Davidson area and provided information to chart makers like Bob Hudgins about obstructions and hazardous areas on the main channel and in the creek areas. Comdr. Carolyn Parker, left, presents a teaching award to Jim Martin. (Courtesy of Lake Norman Power Squadron.)

The squadron's most significant contribution to the community is the education of boaters of all ages through the U.S. Power Squadron Boating Course. The Lake Norman Flotilla of the U.S. Coast Guard Auxiliary and the North Carolina Wildlife Commission offer education to boaters as well as boat examinations and licenses for water activity.

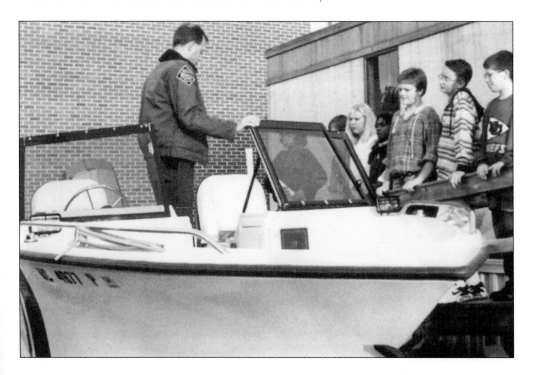

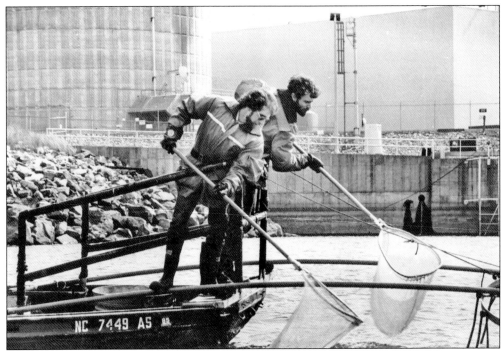

Duke Power Company takes the job of environmental safety seriously. Water is tested on a regular basis with special attention paid to the water discharged from the Marshall and McGuire plants. Duke scientists keep track of the health of fish populations and are always on the lookout for infestations of hazardous marine life like zebra mussels and harmful algae. Crews work to stop mosquito infestations by spraying in shallow coves. (Courtesy of Duke Energy.)

Publications contain specific information about recreation on Duke Power lakes. Annual information is provided to residents and visitors, and an ongoing education program is provided by the Energy Explorium. This hands-on science facility teaches all ages about electricity and the company's relationship with the people who live near its lakes. (Courtesy of Stallings-Sigmon Collection.)

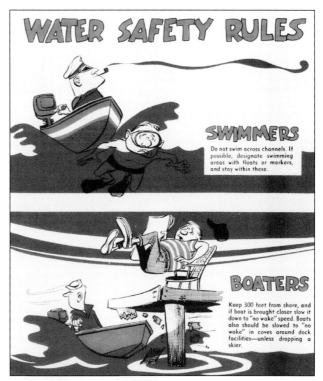

Lake Norman Power Squadron (LNPS) led the way in bringing the Big Sweep to the shores of Lake Norman. The annual event brings Lake Dwellers together to remove litter and trash from the shoreline and islands. Power Squadron commanders Jim Clark, left, and Cindy Jacobs wait for a boat to remove debris. (Courtesy of LNPS.)

LNPS and the U.S. Coast Guard Auxiliary participate each year in National Safe Boating Week on and off the water with a "Know Before You Go" campaign to promote the importance of boating education and safety. (Courtesy of LNPS.)

Duke Power Company supported safety on the lake by providing material and information for boaters. Two *Inland Sea* publications included information about weather, courtesy, safety, and Duke programs to protect wildlife and environmental resources. The company hosted a week-long community involvement workshop in 1984 to provide Lake Dwellers information on boating safety, zoning, real estate, and business development and environmental issues. Held at the technology center at the Cowans Ford site, panel discussions were led by experts and those involved in the topic of the day. More than 750 people participated in at least one program. Marine commissioners Brenda Campbell, left, and Bob Randall lead the program.

Real estate developer James Jennings participated in the activities to discuss the general development of shoreline property and his own commitment to ordered growth on and off the water. A native of the community, Jennings started Lake Norman Realty in 1978.

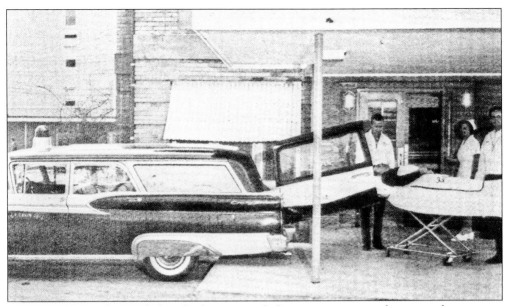

Lowrance Hospital upgraded its facilities to include more emergency doctors and a separate emergency room. The upgrade in emergency services was put to the test in 1965, when the first boating accident occurred on Lake Norman. Even with the specialized care, the swimmer did not survive. As lake activity grew, Lowrance struggled to keep up with the needs for healthcare. By 1980, the hospital facilities that served the community since 1930 were no longer functional as a developing medical center. Mooresville's hospital, founded in 1926, was in need of improvement by 1963. (Courtesy of Lake Norman Regional Medical Center.)

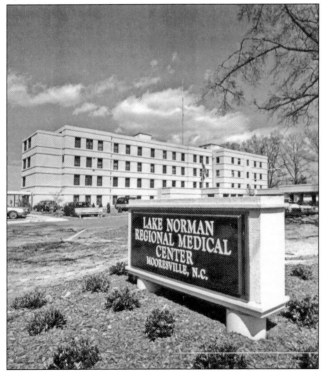

When Lowrance Hospital was sold to Health Care Associates of America in 1981, its status changed to for-profit, ending the era of philanthropic support for the institution. The changes led to up-to-date medical services in a modernized and expanded facility. The hospital grew with the community and soon took on a regional character. That region was Lake Norman. The name change reflected the increasing service area. The new Lake Norman Regional Medical Center sought a new home nearer to its customers. The new site in Mount Mourne was centrally located near Interstate 77 and major roads leading to and from Lake Norman housing developments. (Courtesy of Lake Norman Regional Medical Center.)

Six
Hurricane Hugo

Hurricane Hugo wound its way toward the eastern seaboard, traveling more than 1,500 miles in five days. It came ashore in South Carolina, battering Charleston with 140-mile-per-hour winds. By September 22, one of the greatest storms ever was barreling toward Charlotte with 100-mile-per-hour winds. By the time the storm reached Lake Norman, Hugo had 70-mile-per-hour winds and hurricane-strength gusts, strong enough spawn tornadoes, topple trees, and wreak havoc on lakeshore homes, boats, and power lines. Nearly two million people were without power, some for more than two weeks. (Courtesy of NOAA.)

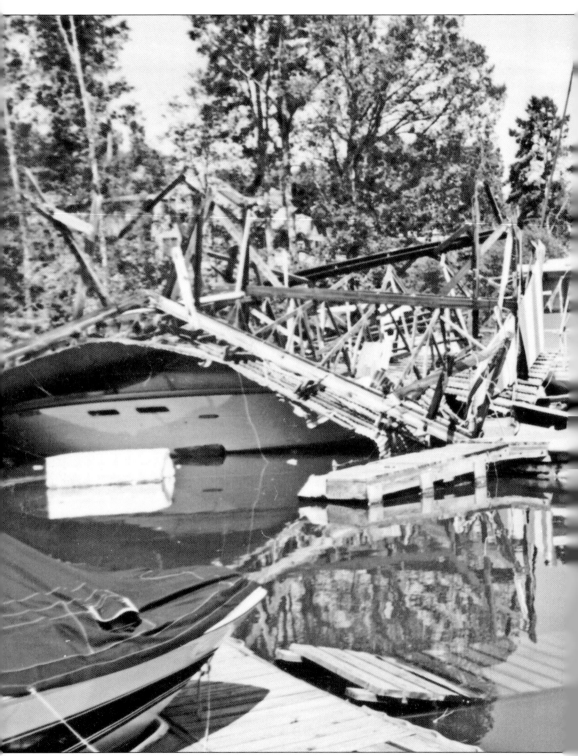

Holiday Harbor marina manager Jack Bennett saw the center section of his floating, covered docks break away and come to rest at the water's edge of a debris-covered yard across the cove. When

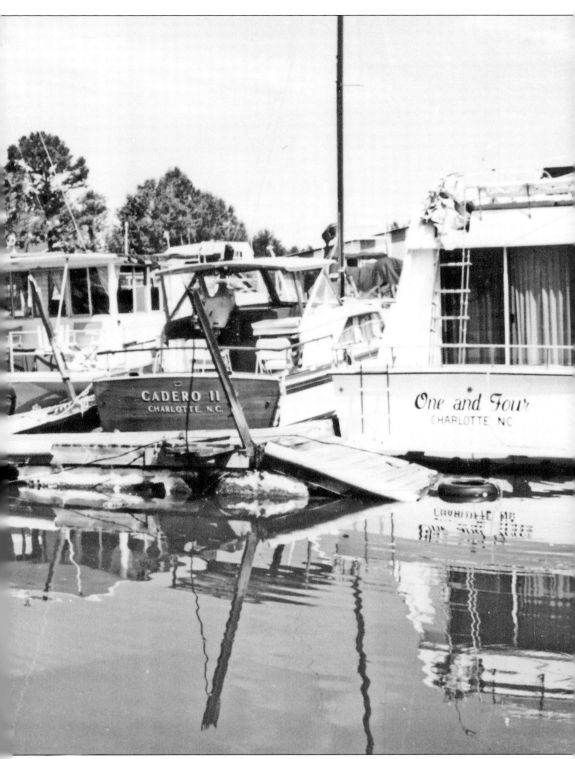
the dock structure was damaged, the roof collapsed onto the vessels. The remaining section was intact but inaccessible except by boat.

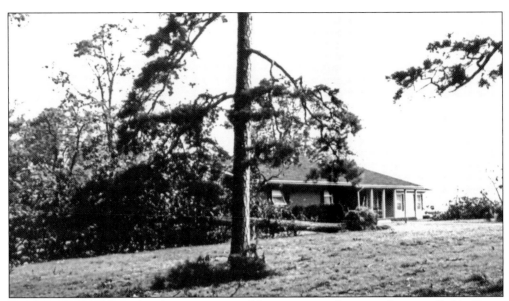

Residents emerged from their homes to a site of destruction—a "war zone," some called it. Trees, tree limbs, utility poles, and power lines were downed in yards and on houses and cars. Forest areas were flattened. Debris filled the streets and roads. Lake water was blowing across Interstate 77 at the causeway connecting Mecklenburg and Iredell Counties. A snowstorm of styrofoam turned the lakeshore white, while boats and pieces of boats, docks, and homes floated in the now-calm waters of the Inland Sea. The Boat Rack Marina's floating docks were destroyed, along with boats of all sizes. Gasoline pumps could be seen floating in the middle of coves. Boats were piled along the shore like a group of toys. Cleanup efforts began, but boaters often had a hard time finding their vessels among the debris.

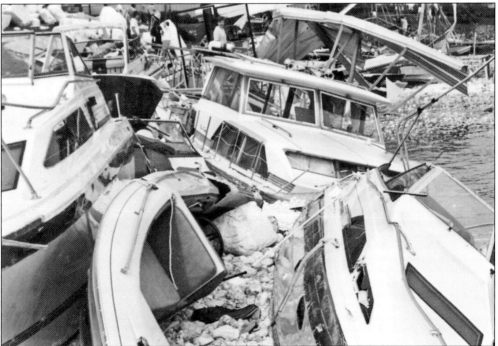

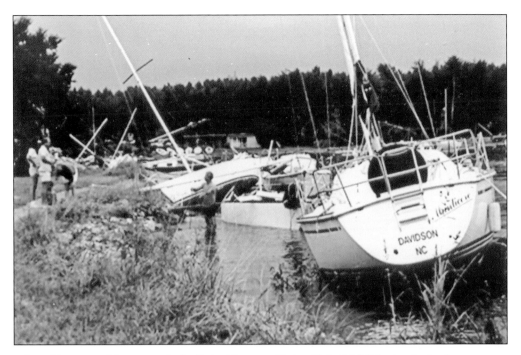

When Hurricane Hugo struck the Lake Norman Yacht Club (LNYC), the docks, boats, trees, and roofs came tumbling down. The club lost almost all its keelboats, a race committee boat, and all the docks on the south side of the cove. Observers compared the scene the morning after the storm to a war zone. LNYC members converged on the site to see piles of boats in the back of the cove, one on top of another. Skippers worked to locate and salvage vessels of all sizes.

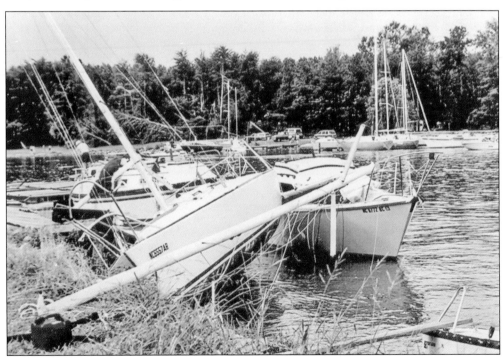

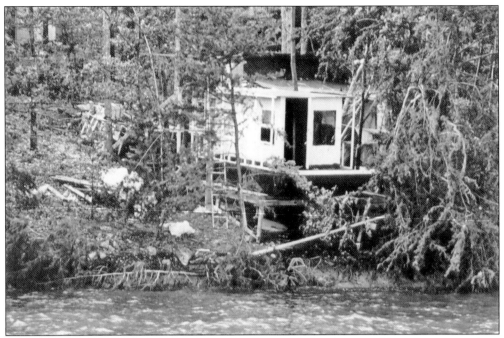

Boats took the full force of the storm. Moored at floating docks, they were blown away, sometimes with the dock, to coves and shorelines. Some vessels were found floating or beached several miles away. Lake Dwellers, part-time and permanent, found their houses nearly destroyed by fallen trees and ripped roofs. Power was out. Duke Power Company crews were overwhelmed with the damage, and people worked with their neighbors to get through the storm's aftermath. Destruction turned to piles of debris. In some areas, it was as if Carl Blades and his bulldozers were back, clearing the land for the lake. Roofs were repaired. Roads were cleared. Docks were rebuilt, and boats were returned to their moorings. There have been other storms and other damage. Nothing, though, was like the day Hurricane Hugo came to Lake Norman.

Seven
LEGENDS, STORIES, AND WHAT WAS THAT?

Every community has its myths and legends—even a community whose main street is a river. Lake Norman has tales of catfish as big as Volkswagens, monsters lurking in the depths of the main channel, and planes crashing and flying under the water. One legend is not only the first but also a tale of real people enjoying an extraordinary adventure. It is the story of Long Sam, "the Girl in Black." People heard a plane flying low over Mooresville and set out to solve the mystery of the lost pilot. Who designed the Roosevelt dime, a work of art owned by nearly every American? These three stories, mysteries of sorts, were born of fact and embellished over the years to become part of the fabric of the community. (Courtesy Fletcher Davis Studio.)

The story of "Long Sam: the Girl in Black" appeared in the *Mooresville Tribune* on a Thursday. Two days later, people were calling from all over asking questions of editor Tom McKnight and photographer Fletcher Davis. Kays Gary, columnist for the *Charlotte Observer*, called to say that if the girl in black really existed, he wanted to see her. McKnight agreed and arranged for a meeting. Gary's article appeared in the *Observer* on Sunday, August 4, 1957, describing her as a fairy tale, only real. He called McKnight's prose neck-tingling and Davis's photographs magnificent. His column, headlined "Will Long Sam Become Cinderella?", touched off a wildfire among American newspapers, fed by the Associated Press with stories datelined Mooresville, North Carolina. Nicknamed "the Backwoods Beauty," "Nature Girl," and "Long Sam," Dorothy Brown became an overnight sensation. (Courtesy of Stallings-Sigmon Collection, a Fletcher Davis photograph.)

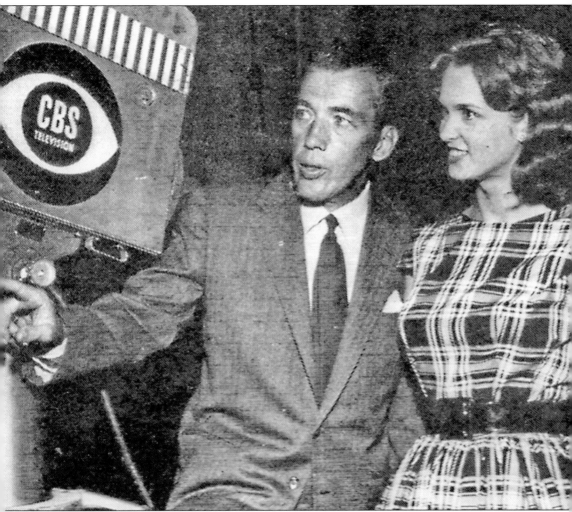

Ed Sullivan invited Dorothy Brown to New York City. She made the trip with McKnight and Gary, and enjoyed Sullivan's hospitality with diners and a Broadway shows, including the hit of the year, *L'il Abner*. *Life* magazine called Brown a "living doll" and the "Carolina prototype for Long Sam, heroine of the Al Capp cartoon" in a two-page spread on August 26, 1957. Everyone, including *Newsweek*, the *Los Angeles Times*, the *$64,000 Question*, and Steve Allen, wanted to interview Dorothy, a girl who just wanted an education so that she could "be somebody." In the end, Dorothy took the $1,000 from her appearance on Ed Sullivan and returned to Mooresville. She took advantage of the opportunity for an education and graduated from the Woman's College of the University of North Carolina with a degree in education. Most people asked why she became the country's darling. It seemed the world loves a Cinderella, someone whose freshness and honesty makes everyone feel better. McKnight and Davis said, "If she hadn't been by the well that day, if Duke Power hadn't planned the lake; who's to say what would have happened." They agree that if writers ever want a big story, they should write it in August when nothing else is going on. A phenomenon just might be around the next clearing. (Courtesy of the Mooresville Lions Club.)

Words are important, but a picture is worth a thousand of them any day. Fletcher Davis may have been thinking just that when he joined Tom McKnight on an excursion in the wilds of the new Duke Power lake. Near the river and through the woods was the photograph of a lifetime, just waiting for Davis and his camera. A Mooresville native, Fletcher was the *Tribune* photographer and winner of at least five North Carolina Press Association awards. A talented artist, his work graced the South School production of *Hiawatha* at Hood Field, the Mooresville Mills' logo, and the walls of Ed Kipka's dairy bar. He recorded the growth and development of the Mooresville Cotton Mills and captured the Mooresville Moors in their best baseball form. In a 1983 interview, he remembered, "We just came upon this girl at the well and I made a couple of pictures. The rule of a good photographer is to shoot what you see. That's all I did." The truth is that Davis did more than point the camera at a lovely young woman. He captured the essence of a sweet, young Dorothy Brown, a girl who just wanted an education. His photographs made Brown famous and were reprinted in *Life, Newsweek,* the *Chicago Tribune,* the *Miami Herald,* the *Los Angeles Times,* and of course the *Mooresville Tribune.* Davis left the *Tribune* to become a news photographer with Charlotte stations WBTV and WSOC. He worked with ABC in the 1960s, recording the events of the civil rights movement. Throughout his career, he maintained a working photo studio in Mooresville and always took time to record events and the people involved in them. He maintained, "no event or activity is without merit and recording large and small events is the responsibility of a photographer." Davis was true to that belief and shared it with young photographers throughout his life.

Who Designed the Roosevelt dime? Was it the U.S. Mint's chief engraver, John Ray Sinnock, whose initials appear on the coins first minted in 1946, or was it sculptor Selma Burke, whose sketch of the president for a relief in the Recorder of Deeds building bears an uncanny resemblance to the portrait actually used? Sinnock submitted a design on October 12, 1945, to the Federal Commission of Fine Arts. The committee rejected it, and his second design was submitted on January 6, 1946. Three years earlier, in 1942, Burke was awarded a WPA commission to create a bronze relief of Pres. Franklin Delano Roosevelt for the Recorder of Deeds Building in Washington, D.C. In an interview on CBS's *Sunday Morning* in 1983, Dr. Burke remembered visiting the White House with a roll of butcher paper to sketch the president. The two-hour sitting turned into two days of drawing and molding his likeness. First Lady Eleanor Roosevelt visited Burke to review the images. Unveiled in 1945 by Pres. Harry Truman, the sculpture is only one of Burke's works in museums and collections throughout the world. It is widely believed that Burke's Roosevelt image was used by mint engraver John Sinnock to produce the Roosevelt Dime in 1945. However, mint engraver John Sinnock is credited officially for the design. (Source material from the U.S. Mint, Wikipedia, WPA photograph archives, CBS News, and Eleanor Roosevelt Archives.)

In 1995, Mooresville native Selma Burke spoke to an audience in Charlotte advising everyone to "follow your dreams and be something." Her life's motto was "You can be whatever you want to be, but be something." If anyone lived that motto, it was Selma Hortense Burke. Born in Mooresville on December 31, 1900, to Mary Eliza and Neal Burke, she felt the tug of her artistic calling when she "squished the clay" between her toes in a creek near her family's farm. The art world waited while she completed studies to become a nurse in 1924 at the St. Agnes Training School for Nurses in Raleigh and became a successful nurse in New York City. While working, she was hired as a model for a sculptor for $1 per hour. Recognizing that the art world was her real home, she made the most of the experience by sculpting small works in clay in the studio. Those works, so similar to the small clay figures of her childhood, led the sculptor to provide all the materials and guidance she needed to develop her talent. With savings and a scholarship, she entered Columbia University, majoring in sculpture. In 1940, she won the Julius Rosenwald Fellowship for Sculpture and began her lifelong study of North American materials suitable for sculpture. She studied in Europe and America, teaching at the Harlem Art Center, founding the Selma Burke Art Center, and working as a WPA artist during the recovery from the Great Depression. (Courtesy of Stallings-Sigmon Collection.)

Selma herself said many times, "I was born to be an artist." She left Mooresville remembering the feel of the soft clay from the creek near her farm. Knowing that sculpture was calling her, she took every opportunity to become involved in the art world, finally beginning serious studies at Columbia University, completing the masters program in 1941, and receiving a Ph.D. from Livingston College. After studying under Oronzio Maldarelli in Paris, Cornaham in New York City, and Povolney in Vienna, she traveled and studied in Germany and Italy on a Rosenwald and Bochler Fellowship in 1938. She taught at the Harlem Art Center in New York City and was an instructor of art and sculpture at many colleges and universities. Her home state honored Selma Burke with the North Carolina Award in Fine Arts in 1982. It is the highest civilian honor given by the state. The program describes her achievements by saying, "Few artists can claim, as Dr. Burke can, that all America knows and uses their creations. Her portrait of President Franklin D. Roosevelt is the model for the profile on the Roosevelt dime. But the wealth of Selma Burke's art reaches far beyond a single commission. Her work captures much of the excitement and emotion of the twentieth century." (Source material from North Carolina State Archives and Department of State.)

In 1941, Burke was asked by patrons and the Library Board to create a sculpture for the Mooresville Public Library. Because of Dr. W. D. McLelland's many kindnesses to her family, she chose him as the subject of her gift. Burke's *McLelland* rests on a granite block atop a walnut pedestal in the main gallery of the library. It is the only Burke sculpture in Mooresville, though her work graces parks and buildings in Winston-Salem, Salisbury, Statesville, Charlotte, and Matthews. Her extraordinary dedication to art and individual achievement is an inspiration. Selma Hortense Burke died on August 29, 1995, in New Hope, Pennsylvania.

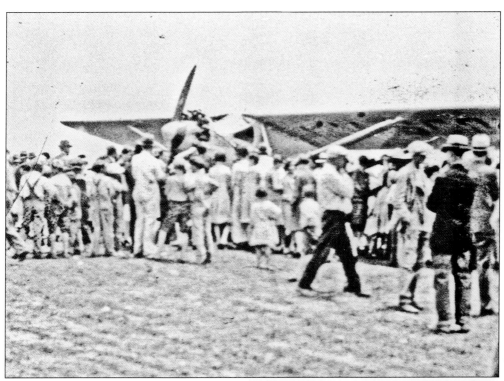

Capt. Emilio Carranza, on a goodwill tour from Mexico to Washington, D.C., flew low over Spartanburg, South Carolina at 1:45 a.m. on June 11, 1928. Flying northeast along the airmail route, he became lost in fog between the Salisbury and Mooresville postal beacons. Carranza flew low over the area to get his bearings and circled the town several times. Fletcher Shinn, caretaker of the beacon and field, heard the plane circling and saw it headed toward Mooresville. Dr. Alan Sloan, on his way home from a late house call, noticed the sound of a plane flying low over the town and recognized that the pilot was in distress. Sloan and policeman Earl Rimmer led a group of citizens and Southern Railway brakemen to Prospect Field to help the pilot. Shinn was waiting with a red flare and joined the group to form a makeshift runway with their car headlights. (Photograph by Dr. Alan Sloan, courtesy of Bob Lineberger.)

Carranza landed safely at 3:45 a.m. on the Prospect Field managed by Fletcher Shinn, kissed the ground, and rode with Dr. Sloan to the Mooresville Depot. There he filed several telegrams before checking into the Central Hotel. After some rest and breakfast, Carranza was welcomed officially by D. E. Turner, president of the chamber of commerce, and took off for Washington at 1:50 p.m. Carranza completed his trip to Washington and toured New York for a month. During his return trip to Mexico, he was killed when his plane crashed in the Piney Wood section of New Jersey. Honored as a hero, his body was returned to Mexico in an U.S. Army train. The Mooresville beacon was removed in 1948, when new technology made the beacon system obsolete. The only thing left is the marker installed by the National Geodetic Survey. (Courtesy of Stallings-Sigmon Collection.)

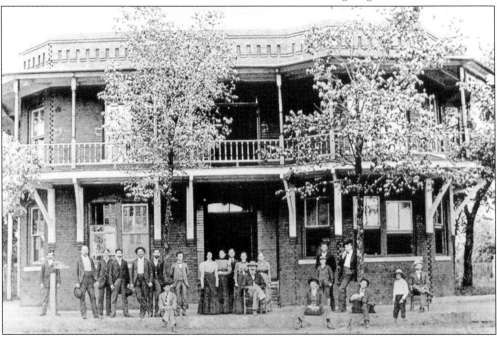

Eight
Port City to Race City

When Burlington Industries decided to close the Mooresville Denim plant in 1999, the town was dealt a blow with the loss of more than 650 jobs and taxes from the town's third-largest taxpayer. Mayor Joe Knox, once employed at Cascade Mills, viewed the loss with an eye toward the diversified economy that started building in 1989. "When we recognized that textile jobs were leaving the U.S., we got to work to head off a disaster. More than 1,000 manufacturing jobs came to Mooresville last year," Knox said. "The good news is that southern Iredell County is thriving with new employers looking for new employees." Mooresville was wounded economically, but first aid came with a roar of engines and a NASCAR logo.

Bahari Racing and driver Michael Waltrip built the first shop in Lakeside Business Park in 1985. The North Carolina Auto Racing Hall of Fame established a visitors' mecca in the Lakeside Business Park at the interstate exit to Mooresville. Just around the corner, Rusty Wallace could be seen landing his helicopter and reporting for work at the Penske Racing South facilities. Just a short drive away is Earnhardt country, home of Dale Earnhardt, Inc.'s "Garage Mahal." Memory Lane Museum takes visitors back to the days when moonshining set the stage for today's auto racers. They even have Sam Brawley's Ford, a local car that was a champion on the winding roads and on the track and is currently part of the Memory Lane Museum collection. (Courtesy Memory Lane Museum.)

Roger Penske, Don Miller, and Rusty Wallace formed Penske Racing South with a new shop and offices in Lakeside Business Park. General manager Miller remembers buying the land for $30,000 an acre to build a state-of-the-art facility. "Bahari and Penske set the standard for a high quality business, a good corporate citizen," said Dan Wallace of the Mooresville–South Iredell Chamber of Commerce. The industry, while not taking over, was certainly a huge factor in the Mooresville economy. For Mooresville in 1989, stock car racing had come to town. (Courtesy of Mooresville–South Iredell Chamber of Commerce.)

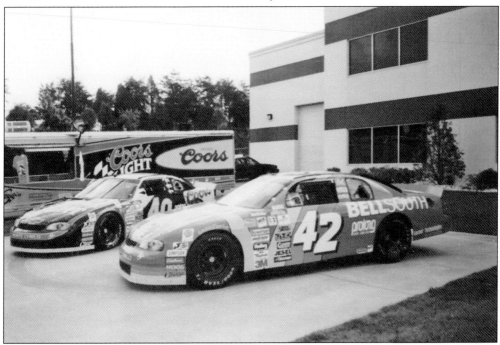

Buddy Baker, a second-generation racer, fell in love with Lake Norman and bought a home there. After winning the Daytona 500 in 1990, he moved his shop to Mooresville. Charlotte Motor Speedway's Humpy Wheeler and driver Dale Earnhardt soon called the Lake Norman area home. Earnhardt built his headquarters, Dale Earnhardt, Inc., just outside of Mooresville. People with names like Joe Gibbs, Ernie Irvan, Robert Yates, Rusty Wallace, and Junior Johnson soon became active in the Lake Norman racing community on and off the track.

In 1995, the community marketed as the Port City of Lake Norman became "Race City USA." By 1999, the reputation as the stock car–racing capital was well deserved, with nearly 70 race teams and supporting businesses calling Mooresville home. There is no racetrack, but the Charlotte Motor Speedway (now Lowe's Motor Speedway) was only 15 miles away. Drivers, team owners, and employees could live at Lake Norman and still commute a short distance to work. Their decisions to call Mooresville–Lake Norman home make auto racing one of the most important industries in the region. Recreation at Lake Norman, a low crime rate, and small-town charm give Mooresville a quality of life that is the envy of other communities. (Courtesy of Mooresville–South Iredell Chamber of Commerce.)

Mooresville leaders recognized the opportunity to make up for textile job losses with an economic development effort to recruit a wide variety of industries. Town commissioner Frank Owens, left, and Mayor Joe Knox, right, worked with Travel and Tourism's Ron Johnson and Wendy Morefield and downtown commission director Wayne Frick to develop plans to tap the new NASCAR market to grow the Mooresville economy.

Tourists from as far away as California and Canada come to get an up-close-and-personal look at racecars and their drivers, sponsors, and mechanics. The idea for a racing museum turned to reality in 1994 with support from Cecile Ebert of Lakeside Business Park. Her family donated $100,000 and provided a 100,000-square-foot building for the North Carolina Auto Racing Hall of Fame. More than 160,000 visitors enjoy the racing exhibits in the museum and are able to visit the 12 team headquarters in the business park. Each year, the hall of fame inducts racing legends on and off the track in a ceremony in Race City USA. (Courtesy of Mooresville–South Iredell Chamber of Commerce.)

A love of stock car racing took hold of people from all walks of life. Teacher Christa McElveen Owens became a fan of the sport and spent her birthday suiting up and taking a few 170-miles-per-hour turns around the track at Lowe's Motor Speedway with Fast Track Racing's Wally Dallenbeck. Such hands-on experiences with stock car racing and NASCAR range from museums like the North Carolina Auto Racing Hall of Fame, Memory Lane Museum to simulators and one-on-one instruction in driving and team support from the pits. (Courtesy of Torie Owens.)

By the early 20th century, racing replaced and even surpassed the textile industry for importance. The community embraced the idea of NASCAR and welcomed the businesses and industries that supported it. Shops attract visitors and customers. Ron Johnson, left, and Wendy Morefield headed the Travel and Tourism Authority. NASCAR Technical Institute attracts students from all over the United States. They come to Race City USA to learn motorsports skills and engage in the excitement of the industry. Sponsors like Budweiser, Alltel, Kodak, Goodyear, and Miller Lite display their names proudly. Mooresville is proud of its industry. It shows, from the painted water tank to the racing paint on the police cars: this is Race City USA. (Courtesy of Mooresville–South Iredell Chamber of Commerce.)

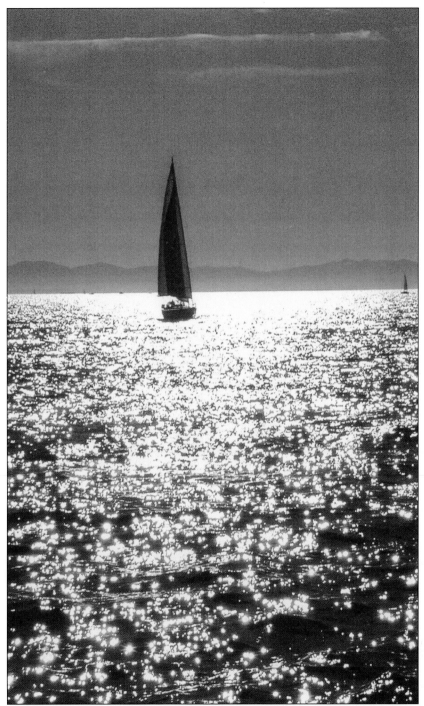

As the communities around Lake Norman headed for the 21st century, connections with the Catawba River remained strong. Rather than a barrier, the "Cattywaba" served as a connector among Lake Dwellers and their communities surrounding the Inland Sea. Deep inside Lake Norman, the Catawba River is alive and well, continuing a never-ending journey from the mountains to the sea.

www.arcadiapublishing.com

Discover books about the town where you grew up, the cities where your friends and families live, the town where your parents met, or even that retirement spot you've been dreaming about. Our Web site provides history lovers with exclusive deals, advanced notification about new titles, e-mail alerts of author events, and much more.

Arcadia Publishing, the leading local history publisher in the United States, is committed to making history accessible and meaningful through publishing books that celebrate and preserve the heritage of America's people and places. Consistent with our mission to preserve history on a local level, this book was printed in South Carolina on American-made paper and manufactured entirely in the United States.

This book carries the accredited Forest Stewardship Council (FSC) label and is printed on 100 percent FSC-certified paper. Products carrying the FSC label are independently certified to assure consumers that they come from forests that are managed to meet the social, economic, and ecological needs of present and future generations.

Mixed Sources
Product group from well-managed forests and other controlled sources

Cert no. SW-COC-001530
www.fsc.org
© 1996 Forest Stewardship Council

Find Your Place in History.